IMAGES
of America

FOREST HILLS

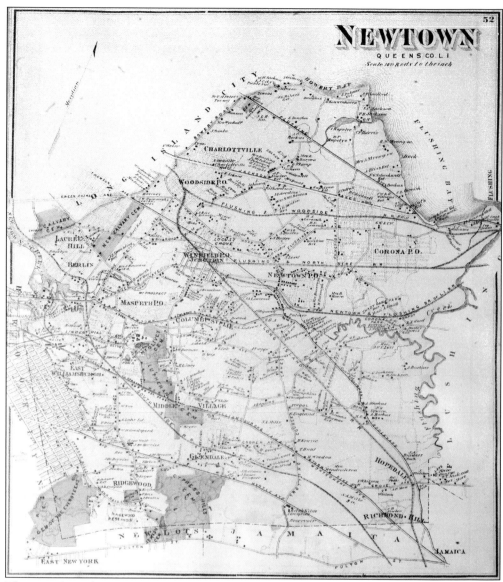

This map from the 1873 Beers Atlas shows Newtown Township, which stretched from the East River to the Flushing River. Hopedale, marked in the lower right-hand corner, centered an area known as Whitepot and later re-branded Forest Hills. Also seen on this map are the properties of some of Whitepot's earliest landowners, including the Backus, Furman, Jackson, Remsen, Springsteen, and Vanderveer families. (Courtesy of Cord Meyer Development Company.)

ON THE COVER: Three months after the United States entered World War I, former president Theodore Roosevelt delivers a forceful speech at the Forest Hills railroad station on July 4, 1917. "We are now bound by every consideration of loyalty and good faith to our allies," he said, "and any opposition to them or any aid given to their and our enemy is basely dishonorable." (Courtesy of Theodore Roosevelt Collection, Harvard College Library.)

IMAGES
of America

FOREST HILLS

Nicholas Hirshon

Foreword by Ray Romano

ARCADIA
PUBLISHING

Published by Arcadia Publishing
Charleston, South Carolina

Printed in the United States of America

Library of Congress Control Number: 2012942169

For all general information, please contact Arcadia Publishing:
Telephone 843-853-2070
Fax 843-853-0044
E-mail sales@arcadiapublishing.com
For customer service and orders:
Toll-Free 1-888-313-2665

Visit us on the Internet at www.arcadiapublishing.com

To Mom and Dad

CONTENTS

FOREWORD

I thought I'd bomb.

In the rows of folding chairs before me sat my first true audience, assembled in the basement of Our Lady of Mercy Church. I was in my late teens in the mid-1970s, and I had never done a comedy routine. Neither had my buddies. We were so inspired by the inaugural season of *Saturday Night Live* that we started a sketch comedy group and put on a show for the Forest Hills Teen Club, which was basically a place for teenagers to stay out of trouble on a Sunday night. They could talk, play Ping-Pong, eat cake, and mingle. (Facebook was still 30 years away.)

From the stage, we scanned the crowd. Every teenager in the neighborhood was waiting for whatever it was that we were gonna try and entertain them with. We were nervous. There were girls in the audience we either wanted to go out with or had already been rejected by. A lot was at stake. We spent moments second-guessing why we were doing this at all.

Then we made them howl.

We did parodies of everything and everyone we knew in the neighborhood. They were broad and ridiculous, and they killed. I loved hearing the laughter, and comedy soon went from a hobby to a personal passion.

A quarter century since I moved out of Forest Hills, this memory of my hometown remains strong. It's one of many. I remember riding my bike to Forest Park and the P.S. 144 schoolyard. I remember how a dollar at Lillian's Pizzeria bought me three slices, a Coke, and a song on the jukebox. I remember the owner of Eddie's Sweet Shop calling me "Mister Big" as I walked in the door. I don't know how or why I got that nickname, but he said it with a huge smile, so I never questioned it.

I held every odd job the neighborhood offered. I had a paper route delivering the *Long Island Press*, stocked the shelves at a drugstore on Sixty-ninth Avenue, and bartended at the Stable Inn. During my stint as an usher at the Cinemart, my younger brother would bribe me with a free lunch from one of the delis on Metropolitan Avenue to let him and his buddies see a movie at no cost. It worked. Those were damn good delis.

My wife and I have raised our family in Los Angeles, and, while it's great here, I do miss my old block in Queens. I miss the sense of community I had with my friends and neighbors. I've been to a lot of places and done many things I never dreamed I could, and when I think of how I got to where I am, I always remember the people and the heart of my hometown, Forest Hills.

—Ray Romano
Los Angeles, California

ACKNOWLEDGMENTS

The history of Forest Hills cannot be told in 128 pages. So many people, places, and moments have influenced the neighborhood that I could not fit them all in, and I hope that readers will forgive my omissions.

I wish I had space to elaborate on the contributions of the many people who assisted this project: Nancy Adgent, Carl Ballenas, Marisa Berman, Seth Bornstein, Joe Coen, Mitchell Cohen, Anthony Colletti, Wallace Dailey, Douglas Di Carlo, Cathy Eiring, Christie Farriella, Frank Gulluscio, Tara Hickman, Erik Huber, John Hyslop, Christopher Orlando, Blythe Roveland-Brenton, May Schonhaut, Bob Stonehill, Brian Sturm, and Stephen Weinstein. Many photographs attributed in this book to Queens Community Board 6 came to the board via Jeff Gottlieb, who runs the Central Queens Historical Association.

In my introductory chapter, I sought to write the most complete narrative yet of a key moment in Forest Hills history, Theodore Roosevelt's 1917 speech in Station Square. To do so, I relied in part on Susan L. Klaus's *A Modern Arcadia*, Edmund Morris's *Colonel Roosevelt*, and Patricia O'Toole's *When Trumpets Call: Theodore Roosevelt after the White House*. Primary sources were provided by Jennifer Brathovde at the Library of Congress and Krystal Thomas at the Theodore Roosevelt Center Digital Library. I also depended upon articles from the *Brooklyn Daily Eagle*, *Flushing Evening Journal*, and *Long Island Daily Star*, as well as early newsletters of the Forest Hills Gardens Corporation and Jeff Gottlieb's essay "Theodore Roosevelt: Friend of Forest Hills Gardens."

I cannot express enough gratitude to Ray Romano for contributing a foreword that proves he has not forgotten his roots. I would have never connected with Ray if not for his incredibly amiable manager, Rory Rosegarten. I must also thank my editor, Caitrin Cunningham, for her guidance and patience.

I understand the temptation to flip through this book quickly, but I urge you to read page by page. Every caption contains facts and stories that would be missed by concentrating on only the photographs.

Lastly, please visit the Facebook page for the book at www.facebook.com/ForestHillsBook to share your own memories of the neighborhood.

INTRODUCTION

John Demarest grew anxious in the fall of 1911. Buyers were not gobbling up parcels of Forest Hills Gardens as quickly as he hoped, despite glowing press about the novel community in New York City. To colleagues, Demarest's concerns seemed premature: Development was still underway, and sales had already climbed to $500,000. But Demarest considered the big picture. A single misstep could derail one of the boldest experiments ever attempted in urban planning.

Even Demarest could not grasp the significance of the project. America's first garden city was conceived several years before he was brought in to lead marketing efforts. By then, the venture had generated headlines from Atlanta to Texas to San Diego. The Sage Foundation, endowed by the widow of railroad magnate Russell Sage, was creating what the *New York Herald* labeled a "modern Garden of Eden." As a first step, the foundation had bought farms and meadows in the city's borough of Queens. On these 142 acres would rise a peaceful suburbia scented by purple lilacs and Japanese holly.

Renderings resembled scenes from a fantasy. At a time when so many New Yorkers were stuffed into squalid tenements, the Sage Foundation's proposal was incongruous. Pedestrians whiffed country air on winding streets. Many of the detached and semi-attached homes evoked the Arts and Crafts cottages of England, with eight to ten rooms each. Frederick Law Olmsted Jr., son of the designer of Central Park, perfumed green spaces with dogwood, jasmine, and forsythia.

Best of all, the Sage Foundation promised Forest Hills Gardens would not cater only to the elite. Robert de Forest, the foundation's president, wrote that even "persons of modest means" could afford to live there. Finally, the middle class—if only its upper rungs—might escape the filth of the big city.

Whimsy, however, did not translate into dollars. Demarest worried he could not sell the plots at a rate that would appease his bosses. The Sage Foundation intended Forest Hills Gardens as its flagship project, but not at the cost of its entire endowment of $10 million. In fact, the foundation planned to profit on this endeavor. Surplus funds would be steered to philanthropic pursuits in other areas.

Forest Hills Gardens seemed increasingly unlikely to break even. The foundation paid about $850,000 for the land alone. Another $1.25 million was earmarked for sewers, streets, and electrical work. Olmsted commanded a hefty fee, as did architect Grosvenor Atterbury, who dipped further into the foundation's coffers to study state-of-the-art construction methods. Demarest's salary as general manager and the costs of his promotional materials were tacked onto the total.

Sales increased as the seasons passed, but not enough for the Sage Foundation. Few doubted the aesthetic success of Forest Hills Gardens. But from a fiscal standpoint, it simply did not provide the instant return the foundation needed. Sage trustees watched the foundation's overall income shrink year after year. By 1917, revenue had plummeted to a nadir.

At this juncture, Forest Hills Gardens confronted the uncertainty that looms over any fledgling community. Could this Arcadia be sustained, or was it destined to the swift end of

8

other fairy tales? In Demarest's view, only one person could prove to the nation that Forest Hills Gardens had arrived. The endorsement of such a luminary might catapult this patch of Queens into the limelight.

If, of course, the person agreed to come.

Fourth of July presented the best opportunity to invite a distinguished visitor. Forest Hills Gardens had hosted Independence Day festivities since 1914, and the annual tradition became more elaborate each year. In 1915, residents participated in a Colonial pageant and competed in tennis matches for a silver trophy. The next year, officials dedicated a flagpole that had been the mainmast of the yacht *Columbia*, a two-time winner of the America's Cup.

The planning for these celebrations was divided between 18 committees. Demarest was the chairman for two: the committees on speakers and entertainment. He knew that his choice for the chief orator was ambitious. But he had reason to think boldly, for his neighbors had already capitalized on the tranquility of Forest Hills Gardens within a cacophonous city. A block west of Station Square, the West Side Tennis Club had become the permanent home of the championships of the United States National Lawn Tennis Association. The tournament would later be re-branded the US Open.

These circumstances bolstered Demarest's confidence that his target would accept the Fourth of July invitation. He tucked his plea into an envelope and scribbled an address: Oyster Bay, Long Island.

Theodore Roosevelt declined most invitations to speak. As much as he enjoyed the bully pulpit, a term he coined, Roosevelt was forced to curtail his public appearances after a brutal Amazon expedition in 1914 cursed him with malaria. Besides his rapidly declining health, Roosevelt had another reason to turn down engagements: He could not keep up with the requests pouring into his home at Sagamore Hill.

Roosevelt handled his complicated schedule with grace. In January 1917, he politely rejected a speaking request from Atterbury, the brilliant architect who designed most of the cottage-style homes in Forest Hills Gardens. Roosevelt's typed letter underscored a deep regret in refusing the opportunity. He was "simply overwhelmed with work." A scrawled message in the margin elaborated, "If I could break this rule, I'd love to attend." But it was not possible.

The former president was in especially high demand for Independence Day. About 500 invites arrived in Oyster Bay, including eight from governors. Bayside, a community merely two miles from Forest Hills Gardens, implored Roosevelt to march in a parade with artillery, firemen, schoolchildren, and two local yacht clubs.

These offers were not alone in Roosevelt's thoughts. Two of his four sons, Archie and Ted Jr., sailed for the front lines of Paris in June, shortly after America plunged into world war. Another son, Kermit, was dispatched to join the British in Mesopotamia. His youngest, Quentin, was training as a fighter pilot and almost assured an assignment despite his bad back and poor eyesight. Even for the hawkish Roosevelt, the prospect of all four sons engaged in conflict weighed heavily. Only his two daughters, Alice and Ethel, would be around to infuse vitality into Sagamore Hill.

But a summer of sulking did not suit Roosevelt. He could not be with all his children, nor could he travel far, yet he would make the most of being close to home for Independence Day. It was a matter of picking the right place.

In a jumble of mail arrived a note from Demarest, representing that new garden city in Queens. Roosevelt read with curiosity.

On June 30, 1917, the neighborhood newsletter, the *Forest Hills Gardens Bulletin*, ran an all-caps headline on its front page: "COLONEL ROOSEVELT ACCEPTS." His speech was set for 11:00 a.m.

Colorful posters of several types heralded the Fourth of July festivities. Malthe Hasselriis, who would earn awards decades later for his miniature portraits, depicted the tower of the Forest Hills Inn after dark. Gene Carr centered his poster on a woman handing out goodies to children. Resident artist Herman Rountree portrayed soldiers on the Green, where Roosevelt would dedicate a new concrete base and bronze collar for the flagpole.

From a dignified home on Deepdene Road, Frederic Goudy and his wife, Bertha, set to work crafting proclamations for the event. Goudy, a master of typeface design, had created similar programs for each of the three previous Independence Day celebrations in Forest Hills Gardens. Due to Roosevelt's popularity, the 1917 edition would remain in demand well into August.

Demarest coordinated the speakers. The Rev. Frederick Burgess, the bishop of the Long Island Diocese of the Episcopal Church, would introduce Roosevelt to the throngs in Station Square. De Forest planned to sit nearby, ready to rally the crowd into a deafening ovation for the ex-president.

The *Bulletin* urged residents to greet Roosevelt with enthusiasm. "Let us see to it that the Colonel will be glad he has come to the Gardens. Called our greatest private citizen, the Colonel isn't private at all. He belongs to all of us, he is the biggest human dynamo in the country. He is our own unequalled Self-starter. Welcome to him."

Men in straw boaters packed the redbrick streets of Station Square, some stuck behind women in hats with face-shadowing brims. A blazing sun cooked the well-dressed crowd on Wednesday morning, July 4. Some sought relief at a small lemonade stand run by the Red Cross. Spectators jockeyed for shade beneath the few trees in the plaza. As the crowd swelled to 2,000, the din exceeded even the clattering of trains.

Station Square's elegant arches and terra-cotta roofs evoked an Old World feel on a day when Europe loomed in American minds. Only three months prior, the United States entered the Great War that had consumed England, France, Germany, and Italy. As a result, Station Square was decked out in even more red, white, and blue than its Independence Day norm. American flags flanked the platform where Roosevelt would speak, wedged between the station's twin staircases. Below the station's roof hung portraits of George Washington and Abraham Lincoln, framed by deep-green cuttings.

A third portrait turned Roosevelt's cheer to ice. Between the faces of Washington and Lincoln was an image of then-president Woodrow Wilson, whose isolationist policies contrasted widely with Roosevelt's "big stick" diplomacy. The two men clashed often. Wilson had apologized to Colombia for Roosevelt's brusque approach to acquiring land for the Panama Canal. When Roosevelt itched for war, Wilson hesitated. Once America jumped into the conflict, Wilson rejected Roosevelt's plea to lead volunteer troops into France. Roosevelt made clear that he thought Wilson should be impeached.

In the entrance plaza, Roosevelt's chilly feelings melted away. These were the moments he cherished. Burgess, who had been reading Washington's famous farewell address from 1796, wrapped up and cleared the way for Roosevelt. As the colonel rose from his seat, the crowd started a series of hurrahs.

Even the latecomers, their backs pressed against the facade of the Forest Hills Inn, would not struggle to hear the roar of the Bull Moose.

Gripping a copy of his speech in his left hand, Roosevelt smiled at the audience. His pince-nez spectacles were perched precariously on his nose when he launched into the address. Roosevelt began with a familiar theme: The United States risked its independence with such a late entry into the war. "We showed a reluctance passing the bounds of ordinary timidity," the colonel smoldered.

Roosevelt blamed the "supine inaction" on pacifists. Though his assault did not name Wilson, listeners easily deciphered his thinly veiled references to politicians fearful of losing German-American votes. Roosevelt accused such "half-hidden traitors" of endangering the country now "at death grips with a peculiarly ruthless and brutal foe."

Roosevelt waved a finger in the air, and he leaned over the temporary balcony as if to pull every listener into his address. He was building up to the ferocious message that would generate headlines in the *New York Times* and the *Brooklyn Daily Eagle*. A crew filming a newsreel for Hearst-Pathé captured the intensity of the moment.

"We can have no 50-50 allegiance in this country," Roosevelt protested. "Either a man is an American and nothing else, or he is not an American at all."

At this climax, the crowd fell into a trance. Roosevelt drew convincing parallels between the ongoing battle with Germany and the revolution against the British. Despite their English blood, the Americans of 1776 fought for liberty. In the Great War, Americans with German lineage must swear allegiance to the country they now called home.

These harsh rebukes formed what became known as Roosevelt's "100 percent American" speech. His energy still lives in black-and-white photographs snapped that day. Beneath him hung a flag with the letters F and H entwined in a branching tree, lest anyone forget where he decided to deliver such a stirring address.

The Gardens celebrated for hours after the speech. Tennis matches pitted men who lived at the Inn against residents from elsewhere in the neighborhood—the "Inns" versus the "Outs." Despite the heat in Station Square, children competed in running contests. They later retreated to the Inn to gorge on ice cream and cake. Olivia Park hosted a play titled *A Masque of Liberty*, with local girls assuming the roles of the Allied powers.

The reveling continued as day turned to night. In the fragile lights of Station Square, couples danced the fox-trot and waltz until the 7th Regiment Band stopped playing after 1:00 a.m. They left smiling and laughing into the warm night.

On July 6, Demarest unloaded his unstinting praise for Roosevelt onto the letterhead of the Sage Foundation Homes Company. He hailed the "wonderful address, which sank deep into the minds of all of us," and predicted the speech would "long be remembered by those who had the distinction to be present." Demarest shipped the letter to Oyster Bay, where Roosevelt stashed it away with other papers.

Two years later, in 1919, Roosevelt died in his sleep at Sagamore Hill. His doctors suspected an embolism in his brain or lungs, but many Americans could not fathom the death of such a vibrant figure at age 60. Thousands of churches set memorials for February 9, which Congress had declared a national day of remembrance. Roosevelt was so beloved that the *New York Times* reported the tributes would "exceed any similar demonstration, at least since the death of Lincoln."

In Forest Hills Gardens, the Inn hosted a speech by one of Roosevelt's close friends, a magazine editor named Lawrence Abbott. Some historians speculate that Roosevelt spoke in Station Square after being persuaded by Abbott, who moved to the Gardens only a few months earlier. If so, Abbott did not make his role in arranging the speech well known. He published a small book in 1920 titled *Impressions of Theodore Roosevelt*, which omitted any mention of Forest Hills.

Station Square did not change much in the years after Roosevelt's death. In fact, his speech may have ensured its preservation for posterity. When Station Square began to deteriorate in the

mid-1990s, a group of local residents compiled a report on its history that most notably included the "100 percent American" speech. That report convinced federal authorities to place Station Square in the National Register of Historic Places, opening it up to sorely needed restoration grants. Today, the site remains almost identical to its appearance on July 4, 1917.

Roosevelt's speech lives on about a mile away, visible through the clean glass windows of a bank on Metropolitan Avenue. Passersby can peer inside to see a mural vibrant with the deep reds and blues of American flags and the greens of ivy creeping onto the walls of the station. After a moment or two, an eagle-eyed pedestrian may spot the face of Roosevelt, about to confirm the arrival of Forest Hills and, undoubtedly, ease Demarest's mind.

Lost in the adoration is the mystery that still lingers over Roosevelt's visit. Why did he settle on Forest Hills for the Fourth of July speech, when so many other suitors were calling? It is unlikely that Abbott alone convinced Roosevelt to visit. Roosevelt's favorite hobby may hold a part of the answer. Late in his second term as president, Roosevelt left his office nearly every afternoon to partake in a pastime so dear to him that he oversaw the construction of a place to play it on the White House grounds. Gone now from Washington, Roosevelt wanted to practice the sport closer to Oyster Bay. The man who had risen to the highest position in the country landed another coveted slot: membership in the West Side Tennis Club.

One

IMPROBABLE CHOICE FOR TENNIS

Inside the old Delmonico's restaurant at Fifth Avenue and Forty-fourth Street, a group of prominent men scanned the menu on December 3, 1912. They watched other visitors enter off the chilly streets of Manhattan and thaw their throats with steak and potatoes. But this group was not focused on dinner. Its members numbered more than 300, and its menu listed only two options: the Bronx and Queens.

Prior to this meeting, the members of the West Side Tennis Club had bickered over every decision but one. They had to move. By most measures, the club's rented home at 238th Street and Broadway was sufficient, with 27 courts covering two city blocks. But the club aspired to steal the national championships from Newport, Rhode Island, and its current location could not accommodate crowds that large. The members had whittled their options for relocation to three sites worthy of the country's most prestigious tennis tournament.

The morning of the Delmonico's meeting, the *New York Times* chose a front-runner with its headline, "Kew Gardens for Tennis." Surprisingly, the *Times* considered Kew Gardens a "very probable" choice, even though the club had rejected the very same site in September. Members argued the $72,000 asking price was too high, the rail fare from Manhattan too expensive.

At Delmonico's, the group mulled two other spots: the Morris Park Estates in the Bronx and a parcel near the Forest Hills railroad station. They took two votes. First, 186 men selected Queens compared to only 126 for the Bronx. Deciding next between Kew Gardens and Forest Hills, the members reached a two-thirds majority. With egg on its face, the *Times* reported the outcome.

Early the next year, the club paid $77,000 to the Sage Foundation for 10 acres of land along Burns Street. Tennis champion Calhoun Cragin, who sat on the club's board of governors, personally supervised the removal of top-notch turf from 238th Street to Forest Hills. More than any other event, this move would define the transformation of Forest Hills from mostly rural scenery in the early 1910s into an increasingly urban landscape by the late 1920s.

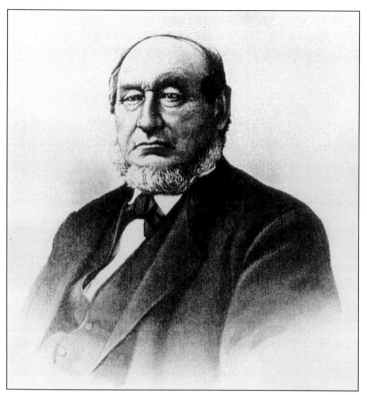

After arriving in Whitepot in 1829, German immigrant Ascan Backus became one of the most prominent and productive farmers in Newtown. Backus, who thrived by selling produce to Manhattan during the Civil War, owned sizeable swaths of modern Forest Hills thanks in part to intermarriages between his relatives and neighboring farm families. He died in 1880, and Ascan Avenue was named in his honor. (Courtesy of Queens Community Board 6.)

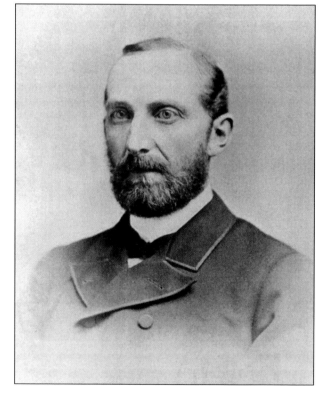

Farmer David Springsteen, seen here around 1896, descended from some of the earliest settlers in Newtown. His ancestors provided a plot of land in 1739 for the Whitepot School, the first educational institution in the neighborhood, near the modern intersection of Woodhaven and Yellowstone Boulevards. (Courtesy of Queens Community Board 6.)

Country Side, Forest Hills, N. Y.

Forest Hills remained mostly countryside into the early 20th century, even after generations of population increases in Newtown. In the 1852 book *Annals of Newtown*, author James Riker Jr. wrote that Newtown jumped from 99 male adults in 1673, when the numbers of women and children were not recorded, to 2,111 residents in 1790 to more than 7,200 in 1850. (Courtesy of Queens Community Board 6.)

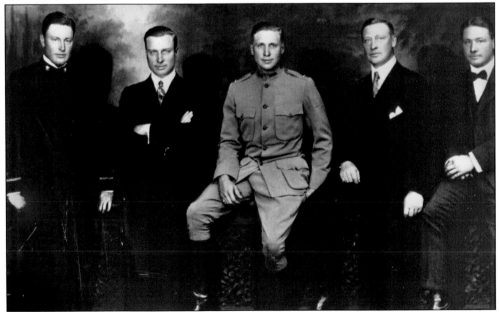

Cord Meyer Jr., who sits flanked by his brothers in this c. 1917 photograph, purchased much of Whitepot from farmers in 1906. The name Whitepot may have derived from the Dutch word *Weisput*, with *put* meaning "pit," since the area was once the bed of a large stream that contained white clay pits. Meyer renamed it Forest Hills after Forest Park. (Courtesy of Queens Community Board 6.)

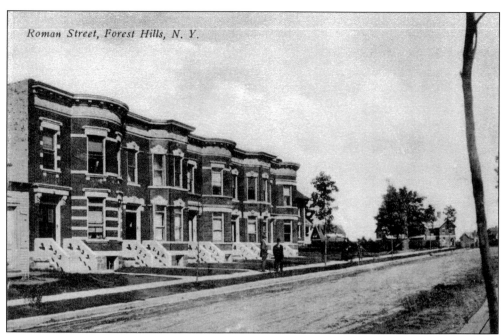

Roman Street, Forest Hills, N. Y.

As his first project in Forest Hills, Cord Meyer built these brick row houses in 1906 on Roman Avenue, modern Seventy-second Avenue, between Austin Street and Queens Boulevard. Meyer's son, George, told the *New York Times* that each row house was offered for $5,500 with a down payment of $550. Distinguished by low-rise stoops and gargoyles, the residences housed the area's first carpenter, electrician, and plumber. (Courtesy of Bob Stonehill.)

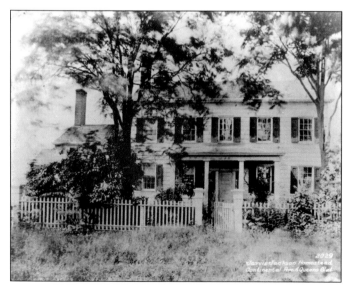

The former home of Jarvis Jackson, a state assemblyman in the 1830s, sits at Continental Avenue and Queens Boulevard in this c. 1910 photograph. Ascan Backus bought the Jackson family farm in 1878. The *Newtown Register* reported that the purchase gave Backus enough land "from which we trust he may be able to realize a sufficient income to spare his declining years from want and penury." (Courtesy of the Forest Hills Gardens Corporation.)

Queens Boulevard, depicted in this postcard, was originally named after John Hoffman, the mayor of New York City from 1866 to 1868 and governor of New York State from 1869 to 1872. The well-trafficked thoroughfare, which runs from Long Island City to Jamaica, was granted its current name after the 1909 opening of the Queensboro Bridge. (Courtesy of Bob Stonehill.)

The expansive farmland and bucolic meadows of Whitepot began to disappear with the emergence of the automobile and Cord Meyer's plans for 6,000 homes on a street grid in Forest Hills. By 1909, the landscape of Queens was transforming so quickly that a resident named James Hendrickson bemoaned the "rapid colonization of our whole island," a concern captured in Clifton Hood's book *722 Miles*. (Courtesy of Bob Stonehill.)

When Wall Street financier Russell Sage died in 1906, his wealth passed to his philanthropic wife, Margaret Olivia Sage. She set aside $10 million for the establishment of the Russell Sage Foundation, tasked with improving social and living conditions in the United States. In 1909, the Sage Foundation bought 142 acres of land from Cord Meyer to create what would become Forest Hills Gardens. (Courtesy of Queens Community Board 6.)

The Sage Foundation contracted architect Grosvenor Atterbury, pictured here, to help execute its plans for a garden city. A Yale graduate, Atterbury had designed the country homes of many wealthy clients, including Sage family lawyer Robert de Forest, who spearheaded the development of Forest Hills Gardens. Atterbury's later projects would include the American Wing at the Metropolitan Museum of Art. (Courtesy of Queens Community Board 6.)

A 1910 rendering depicts pedestrians milling about the proposed entrance plaza to Forest Hills Gardens, later to be known as Station Square. The capped roofs reflect medieval German architecture, while the trees and plantings nearest the station at the far left evoke the garden cities of England. Landscape architect Frederick Law Olmsted Jr. envisioned the plaza as "an important gateway" to the Gardens. (Courtesy of the Forest Hills Gardens Corporation.)

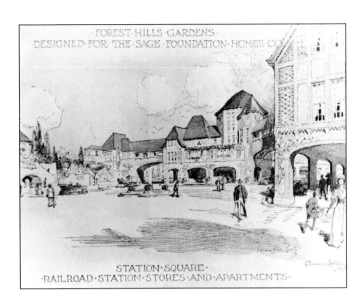

· FOREST · HILLS · GARDENS ·
DESIGNED · FOR · THE · SAGE · FOUNDATION · HOMES · CO

· STATION · SQUARE ·
· RAILROAD · STATION · STORES · AND · APARTMENTS ·

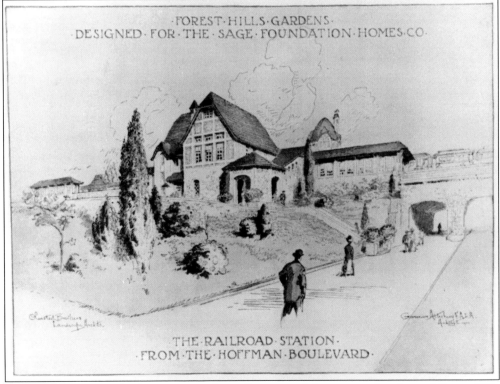

· FOREST · HILLS · GARDENS ·
· DESIGNED · FOR · THE · SAGE · FOUNDATION · HOMES · CO ·

· THE · RAILROAD · STATION ·
· FROM · THE · HOFFMAN · BOULEVARD ·

An outdoor staircase leads commuters from Continental Avenue to the planned Forest Hills railroad station in this 1910 drawing. Susan L. Klaus's book *A Modern Arcadia* recounts how Long Island Rail Road president Ralph Peters initially balked at the station's estimated $30,000 price tag. The LIRR eventually agreed to split the bill with the Cord Meyer Company and the Sage Foundation. (Courtesy of the Forest Hills Gardens Corporation.)

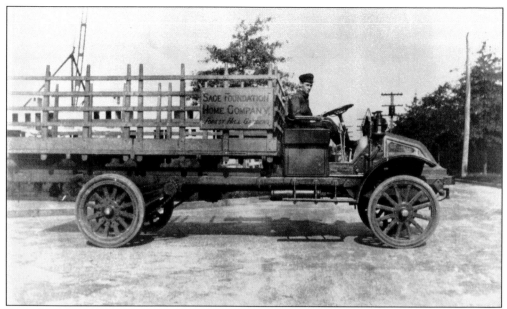

A worker for the Sage Foundation Homes Company drives a construction truck through Forest Hills Gardens. Before Cord Meyer sold the undeveloped property south of Burns Street to the foundation, he had mapped out grid-like streets perpendicular to Queens Boulevard. In contrast, the blueprints of architects Grosvenor Atterbury and Frederick Law Olmsted Jr. featured gently curving roads that followed the contours of the land. (Courtesy of Queens Community Board 6.)

The Sage Foundation cleared this space for the gateway plaza to America's first garden city. The Sage family lawyer, Robert de Forest, ambitiously laid out the objectives of the project in an article that promised "more healthful and more attractive homes to many people" within "striking distance of the active centers of New York." (Courtesy of the Forest Hills Gardens Corporation.)

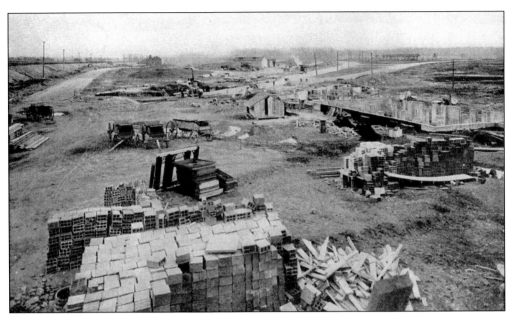

Construction materials are piled high at the future site of Station Square in 1910. Across from the station would rise the nine-story tower of the Forest Hills Inn, linked by pedestrian bridges at the second-story level to three- and four-story buildings with apartments, shops, and offices. (Courtesy of the Forest Hills Gardens Corporation.)

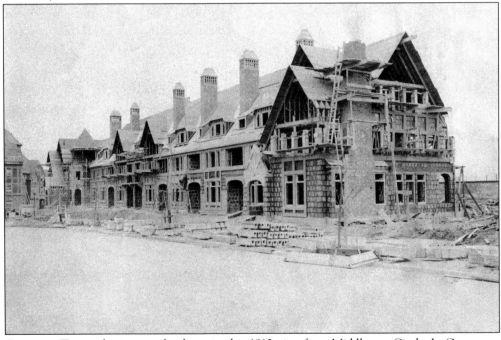

Greenway Terrace begins to take shape in this 1910 view from Middlemay Circle. In Grosvenor Atterbury's attempt to erect appealing, low-cost housing in New York City, he eschewed the handmade elements of homebuilding in favor of cheaper machine-made materials. He also pioneered a simpler process of fabricating foundations, walls, and floors in precast, hollow-core concrete. (Courtesy of the Forest Hills Gardens Corporation.)

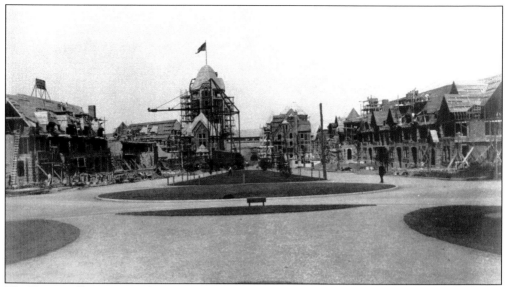

The Forest Hills Inn peers above Greenway Terrace in 1911. As author Susan L. Klaus noted, the Sage Foundation did not explicitly restrict who could buy these homes based on race. However, early general manager Edward Bouton recommended against a mix of "the Hebrew and the Gentile" since they "do not come together in a natural way as social friends and neighbors." (Courtesy of the Forest Hills Gardens Corporation.)

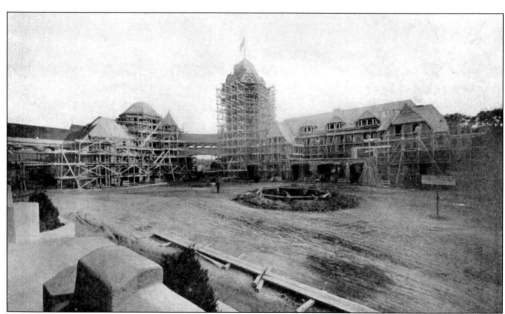

Scaffolding surrounds the Forest Hills Inn during the final phase of construction in June 1911. The same month, the Sage Foundation published a booklet with deed restrictions that forbade property owners from building breweries, slaughterhouses, or cattle yards in Forest Hills Gardens. It also barred hospitals, stables, and "any establishment for the making or preparing of soap." (Courtesy of the Forest Hills Gardens Corporation.)

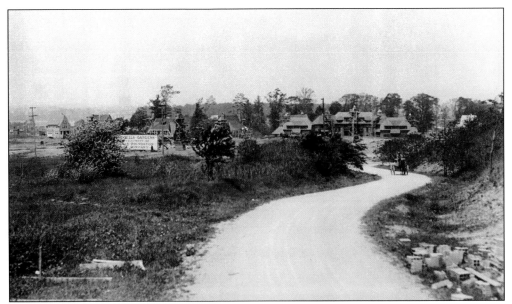

This 1912 vantage point from Forest Park documents the development of Forest Hills Gardens to its eastern edge. A horse and buggy follows Markwood Road, while new homes are sprouting in the background near a sign for the Sage Foundation Homes Company. Some early houses, including on Ingram Street and Greenway North, were grouped into U-shaped units. (Courtesy of Queens Community Board 6.)

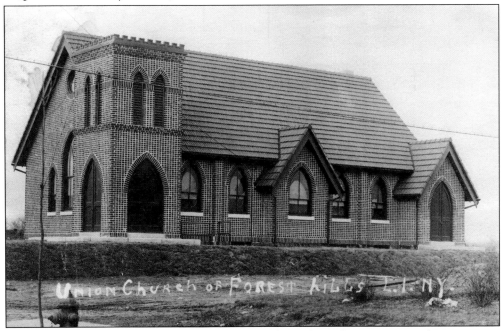

Upon opening in 1912, the Union Church welcomed members of any Protestant denomination. Charles Smith, the president of the church's board of trustees, told the *New York Times* that early Forest Hills would be better off supporting "one church well rather than several churches indifferently." The building at 70-35 112th Street was later renamed the First Presbyterian Church of Forest Hills. (Courtesy of Bob Stonehill.)

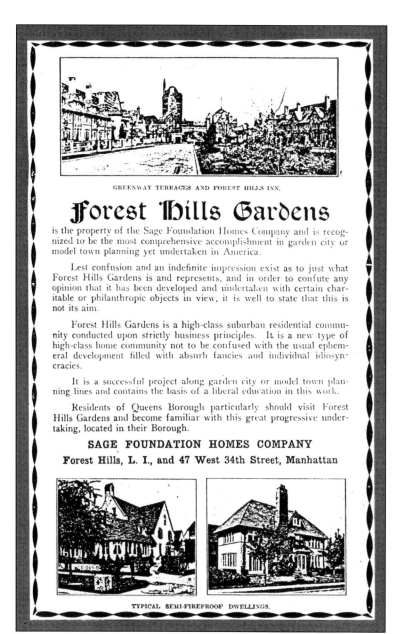

As word spread of the new garden city in Queens, the Sage Foundation worried that its role in the project was creating the wrong impression. Though the foundation had a charitable mission, it did not intend to rent the homes of Forest Hills Gardens to the poor. In fact, the foundation hoped to profit on home sales. The advertisement seen here stresses that Forest Hills Gardens was "not to be confused with the usual ephemeral development filled with absurb [sic] fancies and individual idiosyncrasies." As part of an advertising blitz designed to set the record straight, Sage Foundation Homes Company president Robert de Forest wrote an essay titled "Forest Hills Gardens: What It Is, Why It Is, and What It Is Not." In it, he compared Forest Hills Gardens to other real estate enterprises on Long Island: "It is not a charity. It will not be managed as a charity. Whoever deals with it, whether as tenant or purchaser, will be expected to pay fair value for everything received." (Courtesy of the Queens Historical Society.)

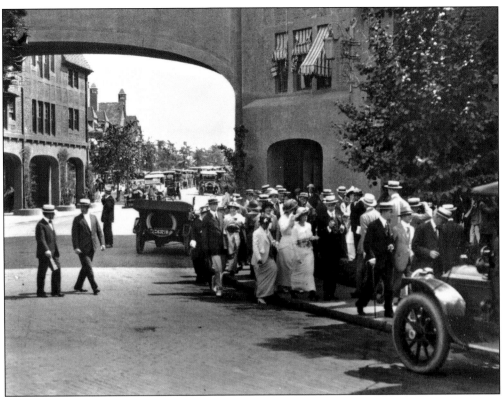

Crowds pack the sidewalk near the Forest Hills Inn in 1913. Opened on May 1, 1912, the 150-room hotel offered a night's rest for transients as well as rental units for residents who commuted to Manhattan via the Long Island Rail Road. Room and board cost $14 to $18. Inside were a restaurant, billiard room, and squash and tennis courts. (Courtesy of the Forest Hills Gardens Corporation.)

At the right of this 1913 photograph, a fountain bubbles in the center island of Station Square while the sun casts shadows on well-dressed men and women. The fountain was the only structure placed in the redbrick plaza by landscape architect Frederick Law Olmsted Jr., who wanted to keep the area clear for cars and pedestrians as well as community gatherings. (Courtesy of the Forest Hills Gardens Corporation.)

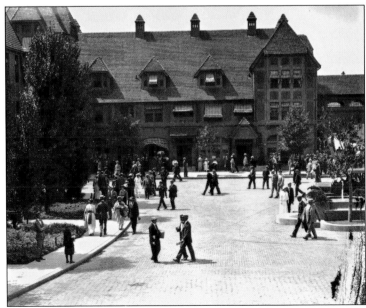

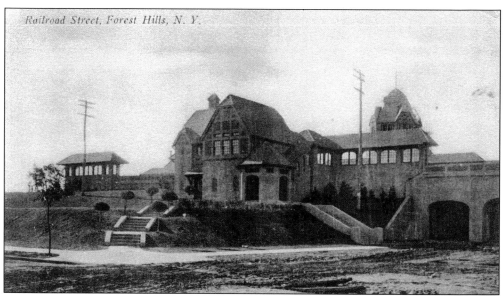

By 1914, the Long Island Rail Road was running 40 trains a day between Forest Hills and Manhattan. The easy commute upped the appeal of living in Forest Hills Gardens, whose population reached 720 in 1915, with 556 adults and 164 children under age 17. This black-and-white postcard shows staircases leading to the station from the dirt roads of Austin Street and Continental Avenue. (Courtesy of Bob Stonehill.)

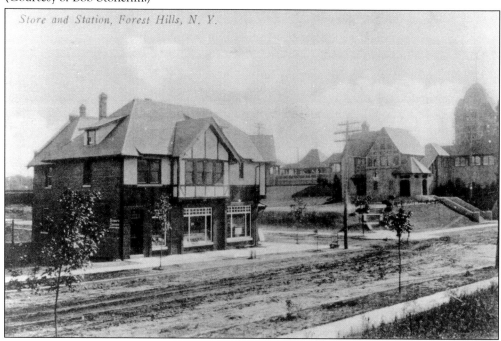

Shops sell chocolates and ice cream on Continental Avenue near Austin Street in the early 1910s. Unfortunately, the sweet scents drew unwelcome customers. In 1915, Station Square hosted a meeting of Queens residents who complained "that their borough is rapidly supplanting New Jersey as the mosquitos' paradise," the *New York Times* reported. (Courtesy of Queens Community Board 6.)

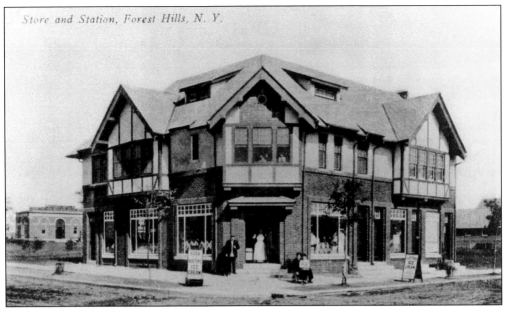

Signs advertise soda and Horton's ice cream for sale in 1914 at Austin Street and Continental Avenue. One of the earliest commercial buildings in Forest Hills, the two-story structure became the home of Cohen's Fashion Optical in the 1990s. The brick building in the background at left was a real estate office for the Cord Meyer Development Company. (Courtesy of Queens Community Board 6.)

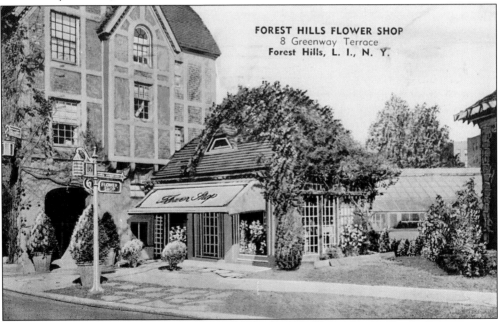

FOREST HILLS FLOWER SHOP
8 Greenway Terrace
Forest Hills, L. I., N. Y.

Near the prominent buildings of Station Square, smaller buildings were constructed on Greenway Terrace to emphasize the low-scale charm of Forest Hills Gardens. In the 1930s and 1940s, this site housed the Forest Hills Flower Shop, one of a handful of local florists that sold flowers with a special distributor's seal that guaranteed they were cut within the last 12 hours of the preceding day. (Courtesy of Bob Stonehill.)

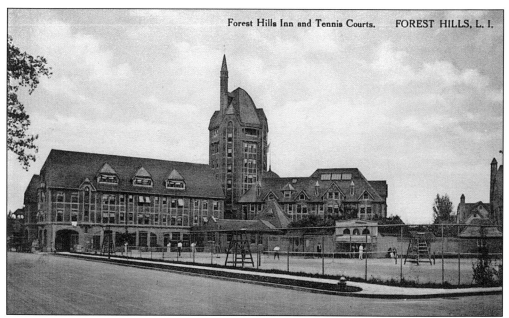

Men play tennis on the courts behind the Forest Hills Inn, billed in a 1913 advertisement as a "new fireproof hotel" only 13 minutes from Manhattan's Penn Station. Just a "few unoccupied rooms" were available, claimed another ad, which called the Inn "attractive, convenient, and well managed." The site of these courts along Continental Avenue is now occupied by the Inn Apartments. (Courtesy of Bob Stonehill.)

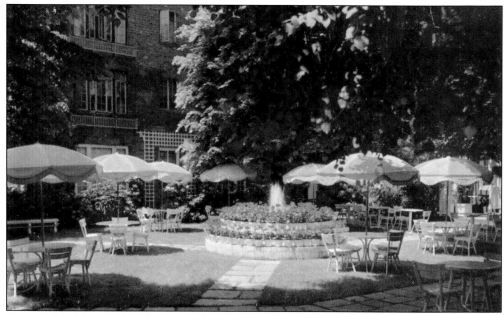

A brick fountain centers the tea garden of the Forest Hills Inn, which became the gathering place that architect Frederick Law Olmsted Jr. hoped it would. Accented by Japanese lanterns in its early years, the garden hosted dinner dances and performances of the Garden Players, a local troupe. It is seen here on a 1950s postcard, with blue-and-yellow umbrellas shading the patio furniture. (Author's collection.)

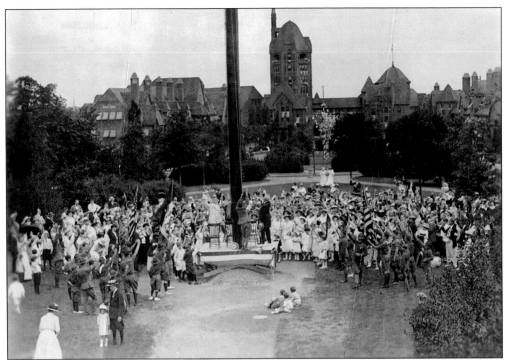

Residents of Forest Hills Gardens gather at Flagpole Green in 1914 for the neighborhood's first major Fourth of July celebration. A 1920 issue of the *Forest Hills Gardens Bulletin* described the festivities: "The exercises of 1914, the initial program, were noted for the camaraderie which can come only in a small community." Independence Day activities would become an annual tradition. (Courtesy of the Forest Hills Gardens Corporation.)

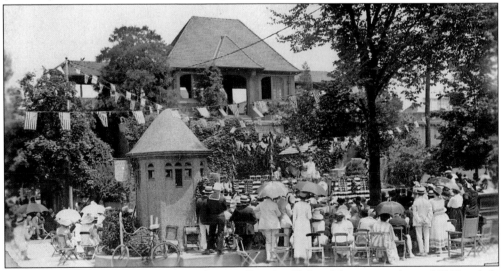

American flags adorn Station Square during a Fourth of July celebration in the mid-1910s, while men in straw boaters and women in large hats listen to a speech. The plaza's center island, which was built with only a fountain, appears here with one of its two new police kiosks. The sign on the kiosk reads, "Police Signal Station—Phone Forest Hills 6329." (Courtesy of the Forest Hills Gardens Corporation.)

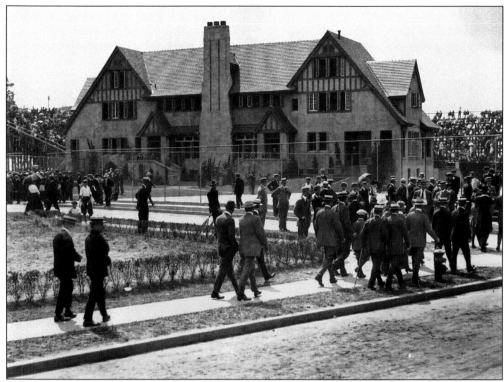

A formally attired crowd walks toward the new clubhouse and grandstands of the West Side Tennis Club in the 1910s. As the club angled for the championships of the United States National Lawn Tennis Association, the association's vice president, A.L. Hoskins, bemoaned the $30,000 clubhouse in Forest Hills as "inadequate" and said that playing the championships there "would be a farce." (Courtesy of the Forest Hills Gardens Corporation.)

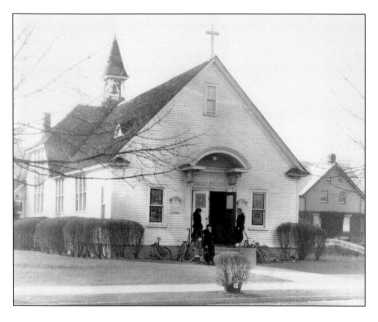

The Chapel of Our Lady Queen of Martyrs, seen here around 1916, became the first site for Catholic worship in Forest Hills. Before the chapel was built on Fife Street (modern Seventy-first Road) Catholics often traveled to other parishes. At the first Mass in Forest Hills on November 24, 1912, a congregation of 107 people celebrated in a house at 50 Fife Street. (Courtesy of the Forest Hills Gardens Corporation.)

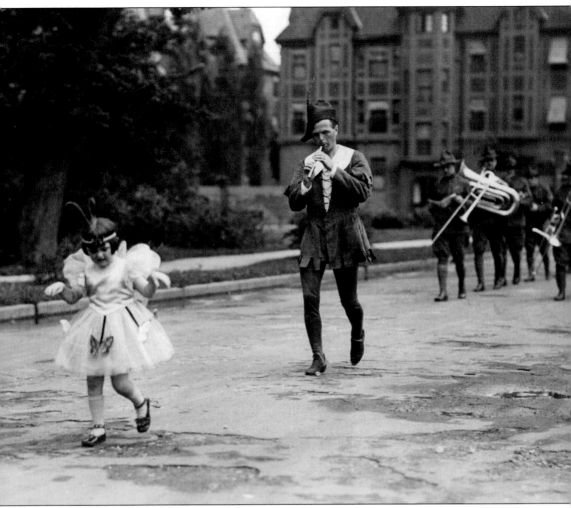

Parades, especially involving children, were popular among the early residents of Forest Hills Gardens. Here, a small girl with butterflies on her dress and antennae on her head marches down Greenway Terrace, followed by a man dressed as the Pied Piper. This image is dated 1915 in the archives of the Forest Hills Gardens Corporation, but it might actually come from July 4, 1922, the first time that the Gardens included a parade in its Fourth of July program. At the 1922 parade, Harvey Warren led the way as the Pied Piper. Trailing Warren were children made up as fairies, sunbeams, and Colonial figures, many of them hoisting signs. According to the *Forest Hills Gardens Bulletin*, the parade "marched over several of the down town streets of the Gardens and then passed the reviewing stand of Forest Hills, where a moving picture was taken of it, as had been done of every part of the celebration there." Near the end of the parade were Boy Scouts pulling a Community House float. (Courtesy of the Forest Hills Gardens Corporation.)

A pageant of Colonial times marked the Fourth of July celebration in Forest Hills Gardens in 1915. The costumes included drummer boys, generals, and Native Americans. During the American Revolution, many patriots lived in the area. At Alderton Street and Trotting Course Lane sits a cemetery that includes the grave of Col. Jeromus Remsen, who fought in the Battle of Long Island. (Courtesy of the Forest Hills Gardens Corporation.)

People in costume, including a man dressed as Uncle Sam, participate in the pageant of Colonial times in Station Square on July 4, 1915. A block away, the West Side Tennis Club was preparing to host the national championships for the first time. On July 28, carpenters began to erect wooden grandstands that would accommodate 7,400. (Courtesy of the Forest Hills Gardens Corporation.)

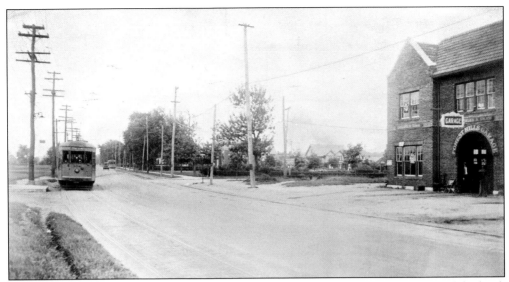

A trolley stops near the Forest Hills Garage in this c. 1915 shot. Over the doorway of the brick building appears the name Charles A. Shaw, partially obscured in this photograph by the hanging "Garage" sign. Another sign advertises Goodrich Tires, marketed as the safest due to the "extra thickness of the Goodrich rubber." (Photograph by Frederick Weber; courtesy of the Queens Historical Society.)

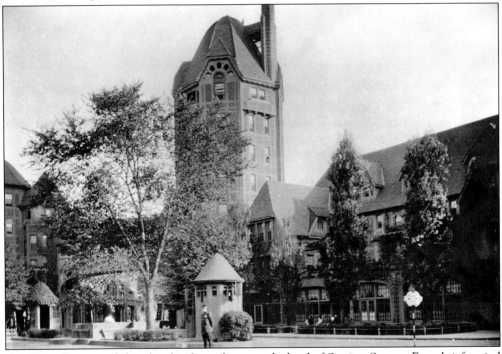

A police officer stands beside a kiosk on the central island of Station Square. For a brief period documented in this photograph, the island included both its original fountain, eventually discarded, and two police kiosks, which were added about 1916. In 1920, a patrolman near the kiosks stopped two men carrying suspicious bundles they claimed were candy. Police discovered the packages contained burglary tools. (Courtesy of the Queens Historical Society.)

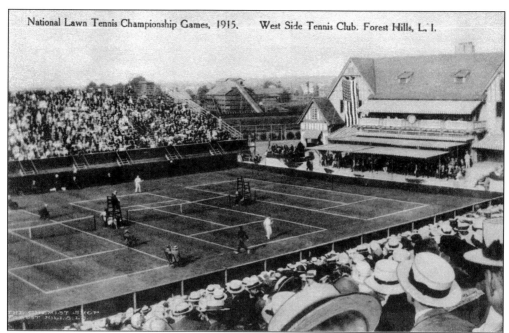

National Lawn Tennis Championship Games, 1915. West Side Tennis Club. Forest Hills, L. I.

On the first day that Forest Hills hosted the national championships, the West Side Tennis Club welcomed a crowd of 5,000 on August 31, 1915. The tournament's second day saw what was then the longest set in the history of modern American tennis title tournaments, when W.M. Hall defeated Wallace Johnson 18-16. In the finals, a 20-year-old nicknamed "Little Bill" Johnston downed Maurice "California Comet" McLoughlin. (Courtesy of Bob Stonehill.)

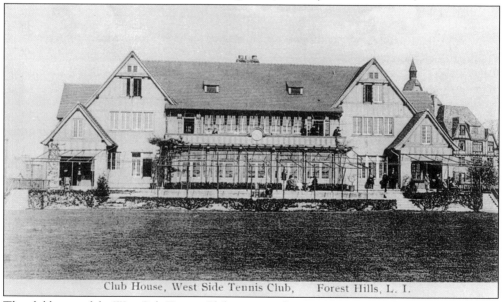

Club House, West Side Tennis Club, Forest Hills, L. I.

The clubhouse of the West Side Tennis Club is pictured on a c. 1917 postcard. Even though about 30,000 fans attended the first national championships in Forest Hills in 1915, suitors continued to proffer new homes for the tournament, including the Crescent Athletic Club in Brooklyn and the Longwood Club in Massachusetts. But the championships remained in 1916, when former president Theodore Roosevelt visited. (Courtesy of Queens Community Board 6.)

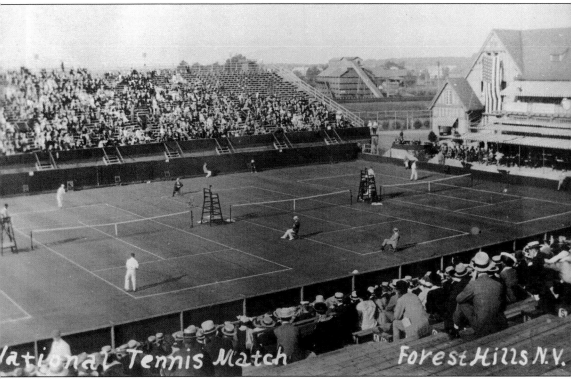

National Tennis Match — Forest Hills N.Y.

By 1920, the West Side Tennis Club was beginning to cement itself as a fixture on the international sports scene. With the exception of 1917, when the national championships were canceled due to America's entry into World War I, the club had hosted the men's and women's nationals every year since 1915. In 1916, the *New York Times* raved about the setting for the highest tourneys of the United States National Lawn Tennis Association: "It would be a hard task to find a better place for the tournament than Forest Hills. There it is, set on the Long Island plains just like a little spotless town." Still, the West Side Tennis Club was not guaranteed future championships. Other locales hoped to bounce Forest Hills from the international stage and claim the nationals as their own. From 1921 to 1923, the Germantown Cricket Club in Philadelphia snared the men's nationals by securing the most votes at USTLA meetings. Officials at Forest Hills mulled how to improve their club. (Courtesy of Bob Stonehill.)

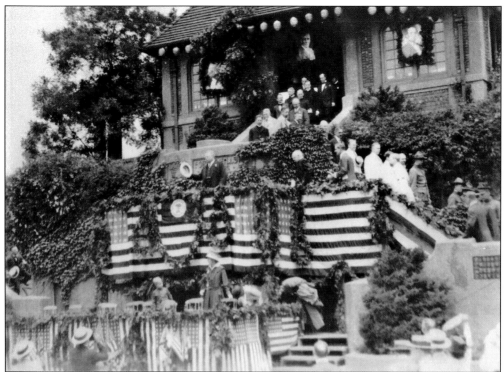

Former president Theodore Roosevelt doffs his hat to the crowd that packed Station Square for his "100 percent American" speech on July 4, 1917. Roosevelt elucidated his patriotic feelings during World War I: "This is a new nation, based on a mighty continent, of boundless possibilities. No other nation in the world has such resources. No other nation has ever been so favored." (Courtesy of Queens Community Board 6.)

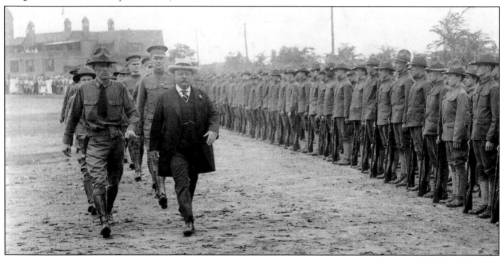

Theodore Roosevelt reviews the Forest Hills Rifle Club following his Fourth of July speech in 1917. He died two years later, initiating numerous tributes in Forest Hills. In the summer of 1923, the Episcopal parish of St. Luke's dedicated its new church after the former president. The cornerstone was laid by the Rev. Frederick Burgess, who had introduced Roosevelt in Station Square. (Courtesy of Theodore Roosevelt Collection, Harvard College Library.)

Bird's Eye View Forest Hills Station.

A postcard captures the platform and tracks of the Long Island Rail Road station beside the Bavarian-style tower of the Forest Hills Inn. The Inn often benefitted from its proximity to the railroad. In June 1915, the state census listed 109 guests at the hotel along with 44 employees, most of whom did laundry and worked in the kitchen and dining room. (Courtesy of Queens Community Board 6.)

The Cord Meyer Development Company, whose Forest Hills office is seen here on Queens Boulevard near Continental Avenue, offered "houses built to order" in "an ideal suburban development." A 1920 advertisement billed an "exceptional opportunity" for a nine-room, brick-and-stucco residence priced at $20,000. A second Cord Meyer office at 62 William Street catered to potential homeowners who lived or worked in Manhattan. (Courtesy of Queens Community Board 6.)

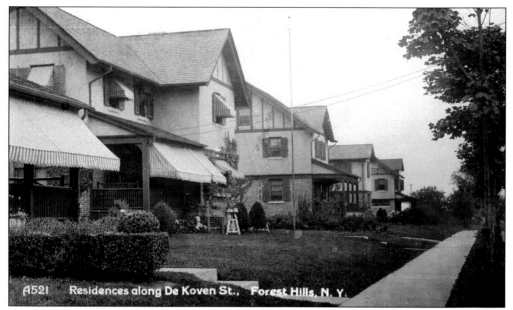

Homes with striped awnings line De Koven Street, which later became Seventy-second Road. Although these houses were outside Forest Hills Gardens, they reflected many of the same "garden city" ideals inspired by urban planner Ebenezer Howard. Howard's 1898 book *To-morrow: A Peaceful Path to Real Reform* envisioned utopian neighborhoods whose residents enjoyed fresh air, open spaces, and nature. (Courtesy of Bob Stonehill.)

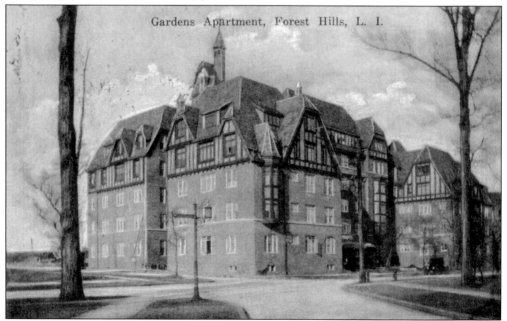

The Gardens Apartment building at Tennis Place and Dartmouth Street had a "wonderful outlook" over the West Side Tennis Club and "woods and farms," according to a 1918 advertisement. The *Forest Hills Gardens Bulletin* insisted the arrangement of the kitchens, with two cozy alcoves in the corners, made them "more attractive to those desiring to use it as a breakfast room." (Courtesy of Bob Stonehill.)

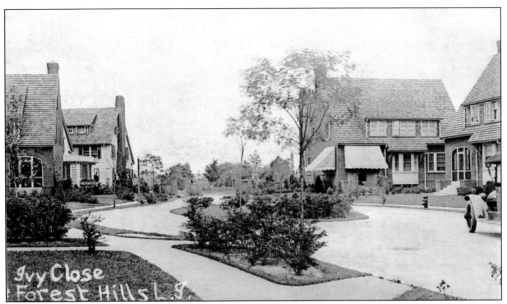

Landscape architect Frederick Law Olmsted Jr. arranged for English and Boston ivy to be planted at the entrances to Ivy Close, which runs parallel to Ascan Avenue between Seasongood Road and Winter Street. The unique architecture drew comparisons to the late-19th-century planned community of Port Sunlight in England and the garden cities of Letchworth, New Earswick, and Hampstead Garden Suburb. (Courtesy of Bob Stonehill.)

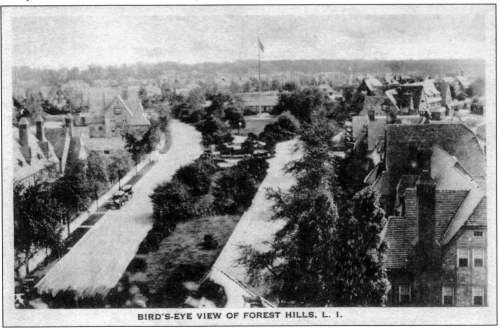

A bird's-eye view of Forest Hills Gardens demonstrates how Greenways North and South proceed from the juncture seen here with Middlemay Circle toward Metropolitan Avenue and Forest Park. All the streets of the Gardens were slightly curved, except for Ascan and Continental Avenues, to discourage their use as thoroughfares, according to a modern essay by Susan Purcell in the *Forest Hills Gardens Bulletin*. (Courtesy of Bob Stonehill.)

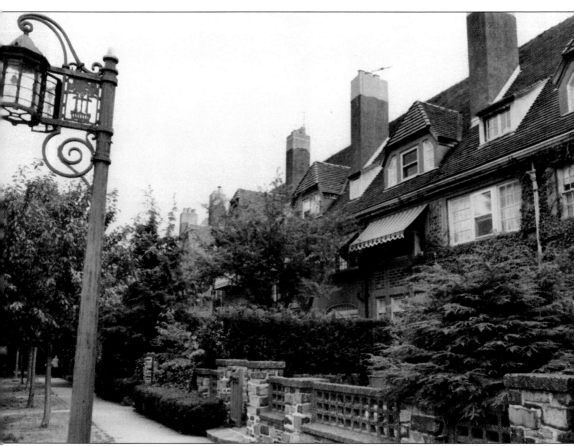

As late as 1921, the Sage Foundation released new maps that proposed expanding Forest Hills Gardens up to Metropolitan Avenue. Two private parks were planned, with one bounded by Kessel Street, Union Turnpike, and Seventy-fifth Road, and another bordered by Metropolitan, Manse Street, Lucy Place, and Seventy-second Road. These ambitious developments would never reach fruition. By the 1920s, the foundation was shifting its focus to social work and its trustees considered selling its interest in Forest Hills Gardens. An important chapter in the history of the area ended in May 1922, when the foundation sold the stock of its homes company for nearly $2 million to a syndicate led by John Demarest, the first full-time general manager of the Gardens. Seven months later, the residents formed their own corporation that would be responsible for the maintenance of streets and sewers as well as new construction. It would also seek to preserve the aesthetic appeal of the tony enclave. The Forest Hills Gardens Corporation remains in place to this day. (Courtesy of the Queens Historical Society.)

Two

A MOVIE PALACE OF THEIR OWN

On the night of December 5, 1922, the silent film *A Tailor Made Man* flickered at the new Forest Hills Theatre on Continental Avenue. The full house chuckled to the pantomime of actor Charles Ray, playing a lowly pants presser who borrows a suit from the shop where he works and masquerades as a big shot. During the duller moments of the film, the eyes of the audience wandered off the screen to examine the theater's interior. They were elated, after years of trudging to Corona or Elmhurst for a movie, to enjoy one in their own backyard.

The grandeur of the theater fit the Roaring Twenties, a period of liveliness and opulence wedged between World War I and the Great Depression. A splendid marquee jutted out from the facade of brick and terra-cotta, and the rose-tinted lobby was scented by floral arrangements sent by well-wishers. To match the movie palaces of the era, the Forest Hills had its own music director and an organ with an ebony console manufactured by the renowned Smith Organ Company of Chicago. From the balcony, a visitor could gaze down and sense the enormity of a space that could seat more than 1,000 people.

Here was a setting worthy of the films of Douglas Fairbanks and Mary Pickford, the power couple of the era, and a cartoon character named Felix the Cat. Every day promised another slate of entertainment, with showings at 2:30, 7:00, and 9:00. But the reach of the theater extended beyond cinema. Tenors sang before movies for an operatic touch. The community gathered to watch newsreels, which, besides newspapers, were the best source of across-the-globe information in a time when radios were expensive and inventors were still tinkering with the forerunners to television.

Across America, new technology revolutionized almost every aspect of life. Automobiles, now affordable to the average family, zoomed through Station Square. The ring of telephones broke the quiet in Forest Hills Gardens. Electricity eased the chores of housewives in the homes being built north of Forest Park. The last vestiges of Whitepot disappeared.

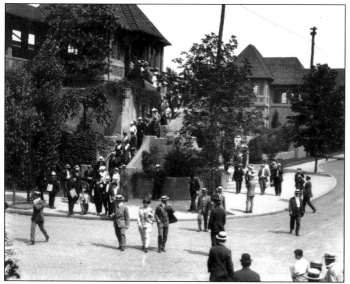

Men sell newspapers to the passengers who disembarked at Station Square on a sunny day in 1920. As more people recognized the ease of commuting between Forest Hills and Manhattan by train, they also desired gathering places beyond the Forest Hills Inn. The cornerstone of a Masonic temple was laid on October 9, 1920, at Queens Boulevard and Gown Street, today's Continental Avenue. (Courtesy of the Forest Hills Gardens Corporation.)

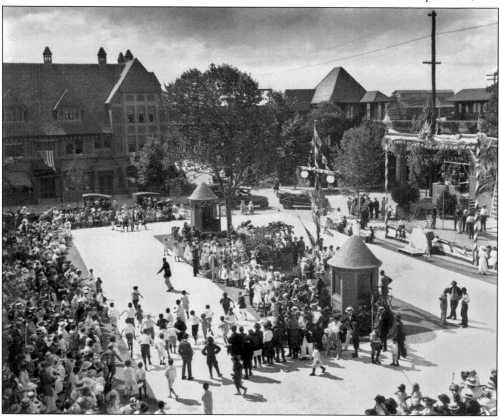

In a Fourth of July contest typical of the early 1920s, children from Forest Hills Gardens race against their neighbors in Station Square. At the Independence Day celebration in 1922, residents attended a parade and golf tournament while "at judicious intervals a magnificent daylight display of fireworks served to maintain the varied interests of the crowds," according to the *Forest Hills Gardens Bulletin*. (Courtesy of the Forest Hills Gardens Corporation.)

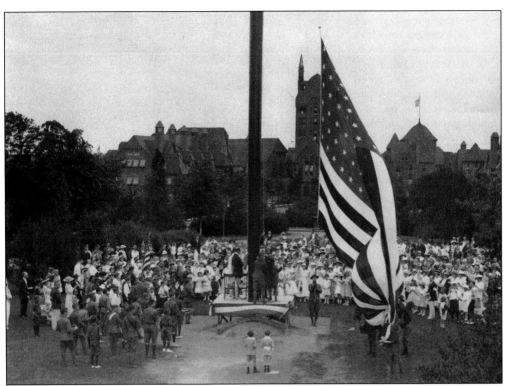

An enormous American flag is raised over Flagpole Green in Forest Hills Gardens in 1920, when the community unveiled a new monument to soldiers and sailors from Forest Hills who fought in World War I. Maj. Gen. Charles P. Summerall, a veteran of the Spanish-American War, addressed the crowd at the October 10 ceremony to mark the debut of the memorial. (Courtesy of the Forest Hills Gardens Corporation.)

Contrary to the 1941 mark, this photograph actually shows Station Square on Christmas Eve 1920. A star-topped tree stands in the island, while a wreath and garland hang from the facade of the station, made to look like a fireplace. At the 1922 Christmas program, the Junior Gardens Players put on a play at a similarly improvised living room on the lower platform. (Courtesy of the Forest Hills Gardens Corporation.)

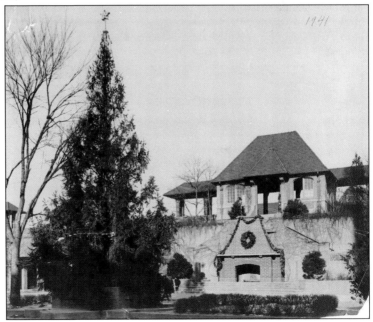

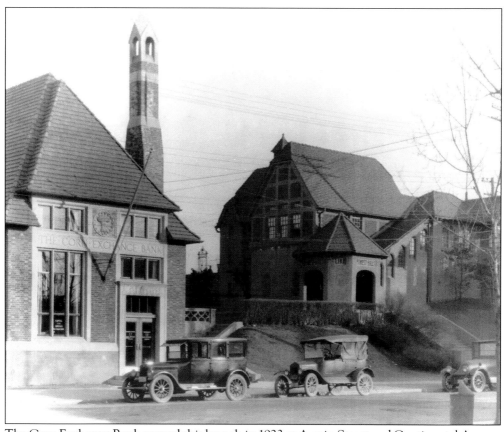

The Corn Exchange Bank opened this branch in 1923 at Austin Street and Continental Avenue on what had previously been part of the railroad station grounds. Designed by the architectural firm of Fellheimer & Wagner, the bank boasted the most modern safety deposit vaults. In this photograph, the hours are listed as 9:00 to 3:00 on weekdays and 9:00 to 12:00 on Saturdays. (Courtesy of the Forest Hills Gardens Corporation.)

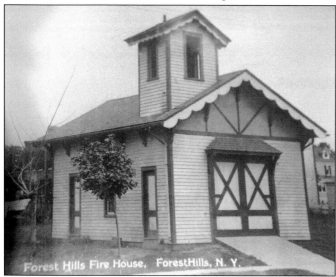

Volunteers were stationed at this small firehouse on Austin Street near Seventy-first Road in the late 1910s and early 1920s. A medieval-style replacement was built in 1924 on Queens Boulevard to house Engine Company 305 and Hook & Ladder Company 151. The second firehouse, which became a city landmark in 2012, has arched window openings and a limestone frieze at its vehicular bay. (Courtesy of Queens Community Board 6.)

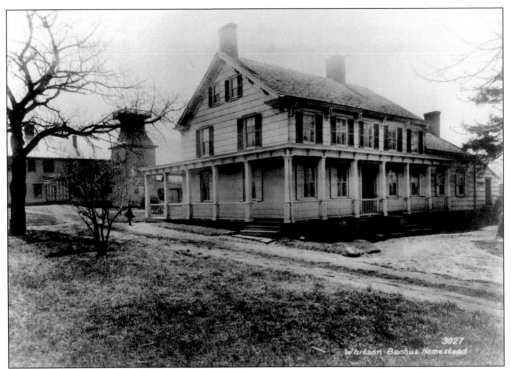

A relic of the neighborhood's roots, the Whitson-Bachus homestead stands in 1920 on the south side of Queens Boulevard at Seventieth Road. The final vestiges of Whitepot began to fade away in this era to the new landmarks of Forest Hills. A block away on Continental Avenue, the Masonic temple hosted a concert in 1922 to raise funds to construct St. Luke's Church. (Courtesy of the Forest Hills Gardens Corporation.)

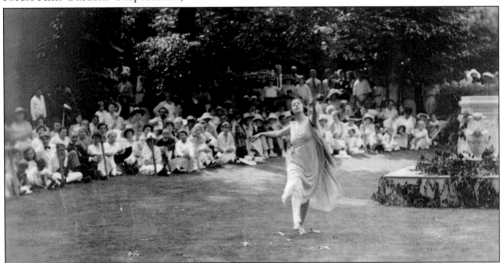

The performance of the whimsical operetta *Cinderella in Flowerland* raised money in 1920 for the construction of a community house in Forest Hills Gardens. With Olivia Park acting as a grassy stage, children dressed as buttercups, daffodils, poppies, and mignonettes over the course of the two-hour show. The effort raked in more than $500. Sales of photographs from the affair also generated funds. (Courtesy of the Forest Hills Gardens Corporation.)

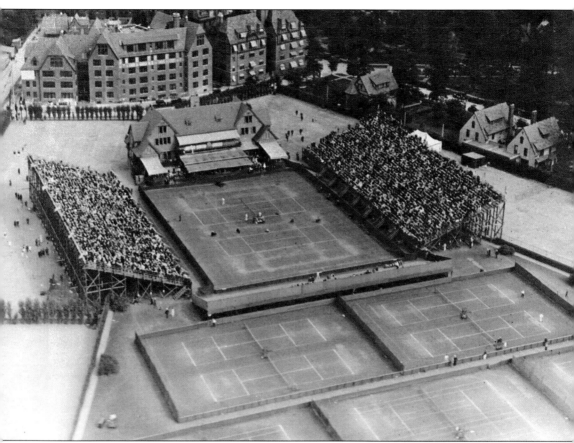

An aerial photograph shows the West Side Tennis Club in 1920, the year it hosted one of its most famous matches. Before a crowd of 10,000 at Forest Hills, future Hall of Famer "Big Bill" Tilden hoped to avenge his loss in the 1919 nationals to "Little Bill" Johnston, whose forehand is still ranked among the best ever. Tilden and Johnston traded the first two sets by identical 6-1 scores. Tilden won the third, Johnston the fourth. Amazingly, play continued even after a plane with a man taking aerial photographs of the match crashed near Queens Boulevard, killing both the pilot and photographer. Umpire E.C. Conlin asked Johnston, "Can you go on?" Johnston nodded. So did Tilden. In a decisive 6-3 set, Tilden beat Johnston and claimed the No. 1 ranking. No less an authority than the *New York Times* predicted the match would "go down on the records as the most astunding [*sic*] exhibition of tennis, the most nerve-racking battle that the courts have ever seen." (Courtesy of St. John's University Libraries, William M. Fischer Collection, Queens, New York.)

Helen Keller, the blind and deaf author immortalized in the 1962 film *The Miracle Worker*, lived for two decades in what she called this "odd-looking house" on Seminole Avenue in Forest Hills. After her stay from 1917 to 1938, the home was demolished to make way for a synagogue. A plaque at 71-11 112th Street denotes Keller's time there. (Courtesy of the American Foundation for the Blind, Helen Keller Archives.)

Swaths of Forest Hills remained rural well into the Roaring Twenties, as seen in this 1923 photograph looking south on Whitepot Road. Cord Meyer's son, George, said that Whitepot Road, which followed the general paths that Yellowstone Boulevard and Fleet Street do today, was "open and also unimproved" when his father purchased Forest Hills in 1906. (Courtesy of the Queens Borough Public Library Archives, Eugene L. Armbruster Photographs.)

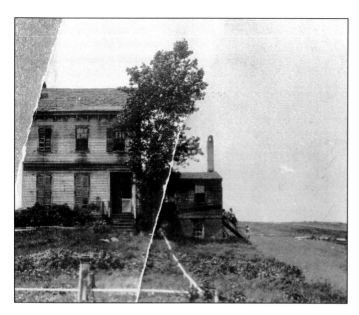

The Jergens Farm, pictured here in 1923, occupied a chunk of property where Alderton and Fleet Streets intersect today. Thirteen lots in this section of Forest Hills were sold in 1936 to the J.J. Realty Company for the construction of homes that still stand there. The *New York Times* reported the area had transformed by 1938 into "a well-populated home community of medium-priced houses." (Courtesy of Queens Community Board 6.)

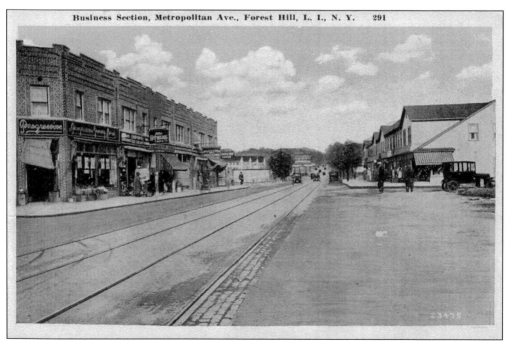

Business Section, Metropolitan Ave., Forest Hill, L. I., N. Y. 291

Trolley tracks run along Metropolitan Avenue in this 1920s postcard that looks east from Seventy-second Avenue. At the far end of the block at left stands Witt's Ice Cream Parlor, the predecessor to Eddie's Sweet Shop. Opposite Witt's on Lucy Place (modern Seventy-second Road), a movie theater named the Metropolis opened in 1925. It would later be dubbed the Inwood and the Cinemart Cinemas. (Courtesy of Bob Stonehill.)

The DeBevoise home at Metropolitan and Seventy-second Avenues is pictured here in April 1923, about the time that the expansive farm on which it sat was sold to a developer. The Gross brothers put up 50 single-family frame homes on the site in yet another project that helped transform southern Forest Hills from a rural to suburban community. (Courtesy of the Queens Borough Public Library Archives, Eugene L. Armbruster Photographs.)

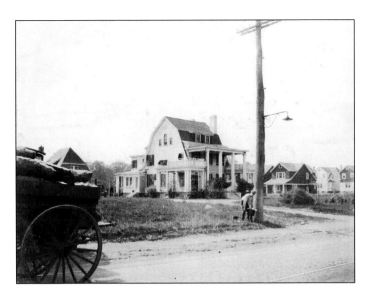

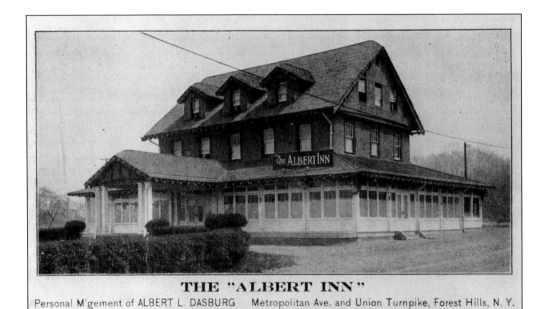

THE "ALBERT INN "

Personal M'gement of ALBERT L. DASBURG Metropolitan Ave. and Union Turnpike, Forest Hills, N. Y.

A'la Carte. Dinner de Luxe, $2.00 Dancing

Known for its fancy dinners, the Albert Inn also hosted a controversial moment in the 1925 mayoral race that pitted Democratic state senator James J. Walker against Frank Waterman, a Republican. Walker claimed that Waterman made a speech at the Inn that suggested he would favor Queens over the other boroughs if elected. Voters went with "Gentleman Jimmy," whose corruption and philandering became legendary. (Courtesy of Queens Community Board 6.)

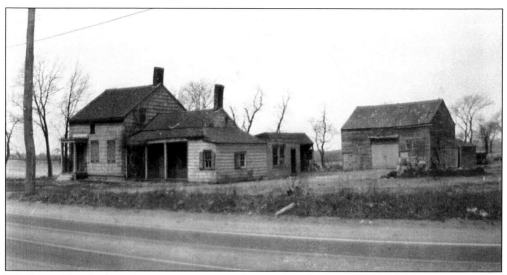

The James Hendrickson house, soon to meet the wrecking ball, sits at Metropolitan Avenue and Union Turnpike in this October 1923 photograph. Historian Lucy Allen Smart lamented the demise of such homes in her 1924 book *History of Forest Hills from Days of the Indians*: "What a deplorable thing it is that these have not all been saved." (Courtesy of the Queens Borough Public Library Archives, Eugene L. Armbruster Photographs.)

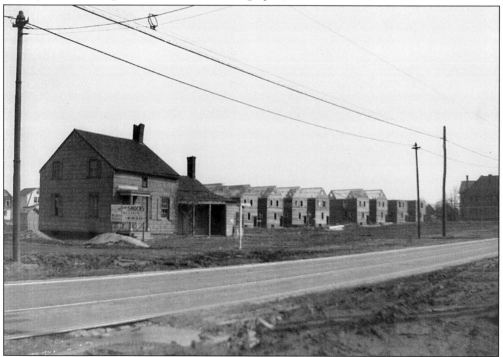

Two-story houses rise on what appears to be Nansen Street in the background of this 1924 photograph. In the foreground is the northeast intersection of Metropolitan and Continental Avenues, where a sign advertises "modern homes" that will soon be available. In August, the Forest Hills Homes Corporation sold four houses on Nansen Street to an attorney named Joseph P. Friedman, who flipped them. (Courtesy of Queens Community Board 6.)

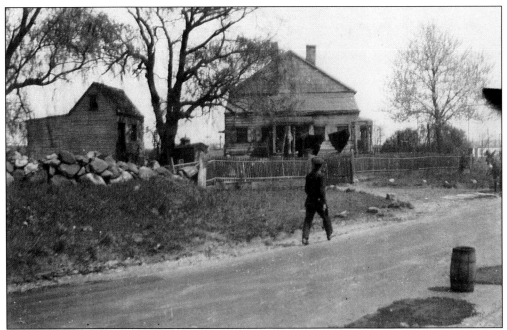

For generations, the Remsen family occupied the property seen here in 1923 on Trotting Course Lane east of Metropolitan Avenue. Public School 144 is co-named after Col. Jeromus Remsen (1735–1790), who grew up at this site and fought in both the French and Indian War of 1757 and the American Revolution. (Courtesy of the Queens Borough Public Library Archives, Eugene L. Armbruster Photographs.)

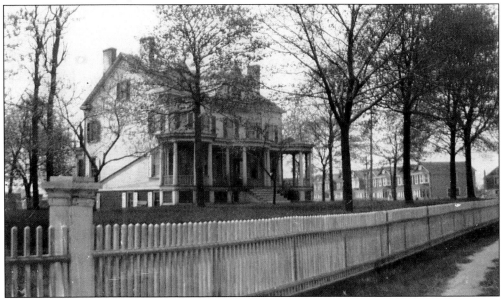

The Vanderveer family owned a massive swath of Forest Hills that stretched from Metropolitan Avenue to the border of Forest Hills Gardens, including this house at Metropolitan and Trotting Course Lane. Much of the Vanderveer property was sold at auction in 1923, ushering in the development of homes on what once was among the largest estates in Whitepot. (Courtesy of the Queens Borough Public Library Archives, Eugene L. Armbruster Photographs.)

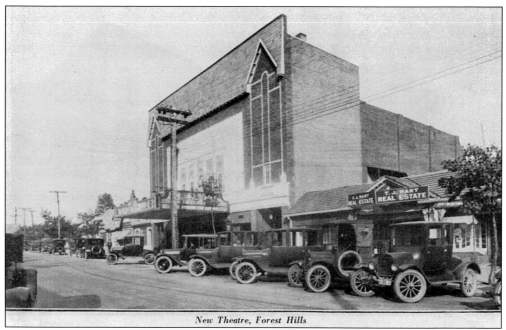

New Theatre, Forest Hills

Cars park on Continental Avenue in 1923 by the new Forest Hills Theatre, where the marquee plugs *The Little Church around the Corner.* A windfall for the fledging Warner Bros. studios, the silent film tells the story of a minister, played by Kenneth Harlan, who advocates for better working conditions in local mines. This photograph also shows the neighboring T.J. Hart Real Estate office. (Courtesy of the Queens Historical Society.)

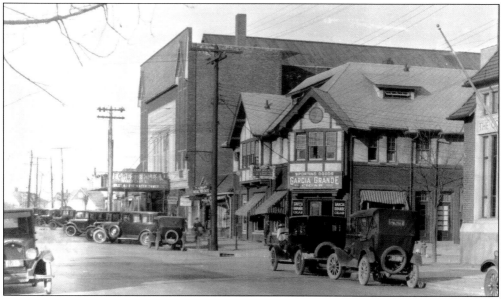

The marquee of the Forest Hills Theatre promotes the film adaptation of Homer Croy's book *West of the Water Tower* in 1924. Starring Glenn Hunter and Ernest Torrence, the movie follows the scandalous union of a preacher's son to an atheist's daughter in a small town. Also on Continental Avenue in this photograph are stores selling cigars, radios, sporting goods, and stationery. (Courtesy of Queens Community Board 6.)

Posters are plastered on a house on the north side of Queens Boulevard on February 8, 1924. An advertisement for the Forest Hills Theatre lists two films: Holbrook Blinn in the Western drama *The Bad Man* and Barney Bernard in the comedy *Potash and Perlmutter*. The poster at right bills the musical *Lollipop* at the Knickerbocker Theatre at Thirty-eighth Street and Broadway in Manhattan. (Courtesy of Queens Community Board 6.)

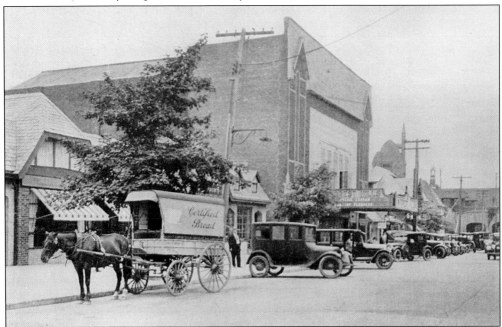

A Certified Bread carriage is parked on Continental Avenue near Queens Boulevard in 1924. In the background, the Forest Hills Theatre screens *A Boy of Flanders*, a tale about an orphan (played by Jackie Coogan) who wanders from his Dutch village and befriends an abused dog. Also seen in the distance is the tower of the Forest Hills Inn. (Courtesy of Queens Community Board 6.)

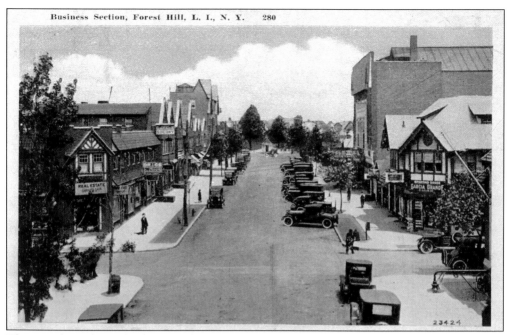

This view from elevated railroad tracks shows the early businesses on Continental Avenue between Austin Street and Queens Boulevard. At left, a real estate office sits on the corner, while signs up the block bill a pharmacy and Socony, the Standard Oil Company of New York, which evolved into present-day ExxonMobil. At right, pedestrians stroll past Garcia Grande Cigars and the Forest Hills Theatre. (Courtesy of Bob Stonehill.)

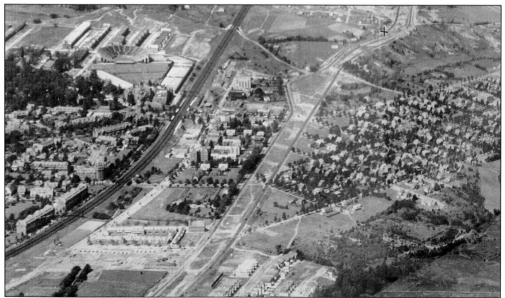

The left side of this photograph captures a stretch of Queens Boulevard from about Seventy-fifth Avenue to Yellowstone Boulevard. By the mid-1920s, Forest Hills began to approach its modern look with businesses along Continental Avenue and homes north of 108th Street. However, large portions of land between Austin Street and Queens Boulevard are still undeveloped in this westward aerial shot. (Courtesy of Cord Meyer Development Company.)

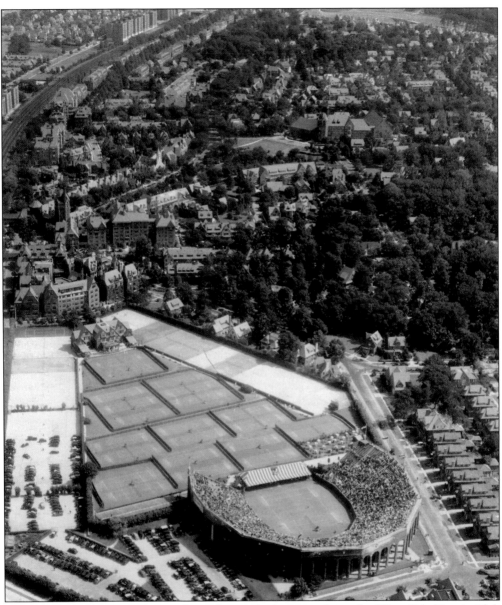

After three consecutive years without the men's championships, the West Side Tennis Club embarked in 1923 on a project that would guarantee Forest Hills a permanent place in sports history. Previously, the club accommodated the crowds from major tournaments by erecting wooden grandstands that boxed in the courts near the clubhouse. Not only were the grandstands costly to construct and demolish every summer, but they also knocked out six to eight courts during the club's peak months. In a radical move, the club asked architect Kenneth Murchison to design the only tennis stadium in the United States, a horseshoe-shaped venue that could seat about 14,000. The price tag would be a whopping $150,000. To ensure the stadium's success, the club's members cut a deal with the USLTA that awarded them a series of major tournaments over the next decade. Astonishingly, construction on the stadium began on April 9 and proceeded so swiftly that the inaugural match was held just four months later on August 10. (Courtesy of the Forest Hills Gardens Corporation.)

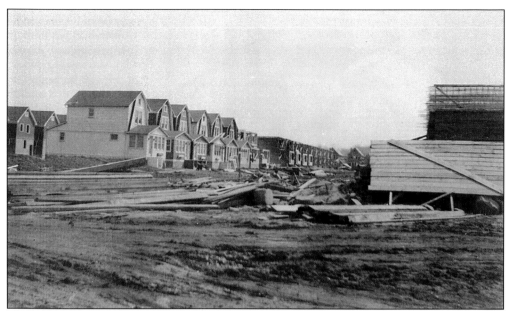

Looking east from Continental Avenue, this photograph from March 31, 1924, demonstrates the progress in construction of homes on Nansen Street. Three years later, Nansen Street was rocked by the arrest of a resident. Grace Peterson, the wife of a racehorse trainer, was accused of aiding a fugitive who fatally shot a patrolman and fled to the Adirondacks. (Courtesy of the Queens Borough Public Library Archives, Eugene L. Armbruster Photographs.)

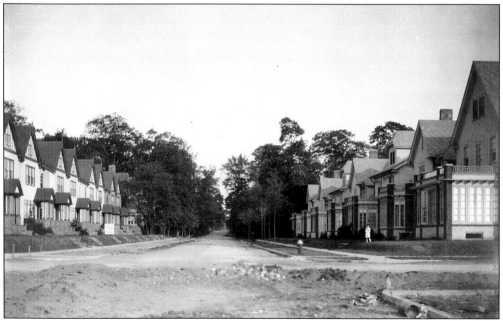

By September 12, 1924, this block east of Seventieth Avenue begins to resemble present-day Forest Hills between Metropolitan Avenue and Forest Hills Gardens. The single-family homes are complete, a fire hydrant has been installed, and the road is mostly paved, except for a portion in the foreground. Magnification of the photograph reveals the sign on the left side of the street reads "For Sale." (Courtesy of the Queens Historical Society.)

The Garcia Grande shop, part of the A. Schulte chain, was among the earliest businesses on Continental Avenue. In January 1926, the Garcia Grande name appeared in ads with a cartoon man who resolved to buy more A. Schulte cigars in the new year. "Instead of burdening his conscience with broken resolutions," the advertisements noted, "he's broadening his smile with better cigars." (Courtesy of the Forest Hills Gardens Corporation.)

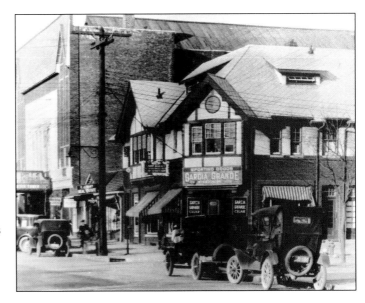

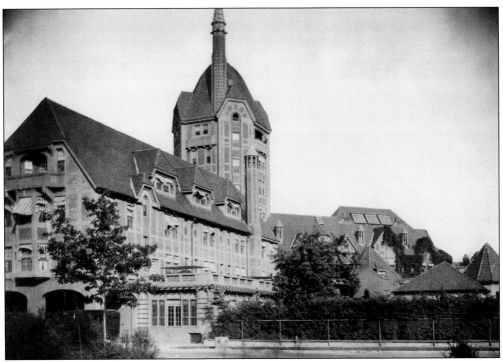

The Forest Hills Inn hosted a fashion show for a charitable cause in the spring of 1924, the same year this photograph was taken. Called the "April Shower," the event in the hotel's sun parlor and ballroom featured style displays, silhouette sketching, and fortune tellers. Proceeds went toward the construction of the community house to be built next to the Church-in-the-Gardens. (Courtesy of the Queens Historical Society.)

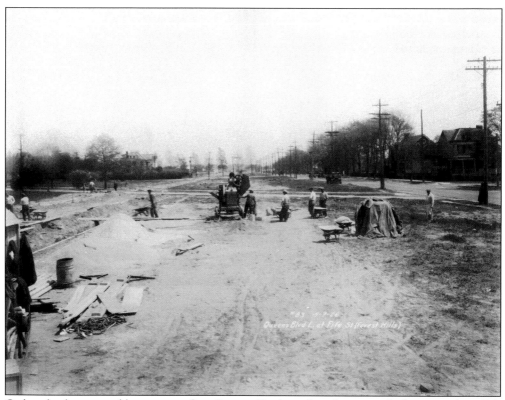

Only a few houses and barren trees line Queens Boulevard in this image looking east from Fife Street (modern Seventy-first Road) in 1926. Plans for a subway running from Woodside to Kew Gardens required crews such as these to tear up some of the boulevard, postponing much-needed repairs to a roadway used by thousands of motorists. (Courtesy of the Queens Borough Public Library Archives, Joseph A. Ullman Photographs.)

After years of fundraising, Forest Hills Gardens finally unveiled its new community house on August 12, 1926. The stone-and-stucco building at 15 Borage Place, just off Ascan Avenue, opened with a gymnasium, swimming pool, auditorium, and dance hall. Broadway and film actor Fred Stone, who has a star on the Hollywood Walk of Fame, performed in a vaudeville act on opening night. (Courtesy of Bob Stonehill.)

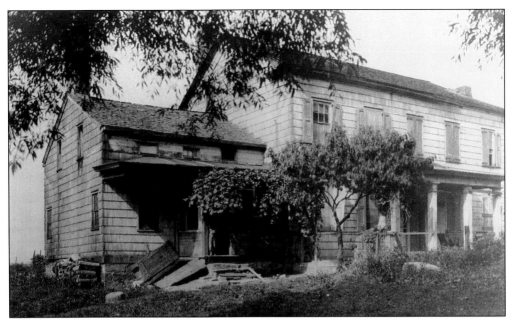

By September 1927, the former home of state assemblyman Jarvis Jackson has deteriorated into an eyesore at Continental Avenue and Queens Boulevard. Unlike the c. 1910 photograph on page 16, this image depicts worn shingles and an unhinged shutter. News of a proposed subway stop at this intersection sent real estate prices soaring in the late 1920s, and the Jackson home was demolished. (Courtesy of the Forest Hills Gardens Corporation.)

In 1820, a livestock farmer named Timothy Jackson moved into this house near the present-day Jamaica rail yards, which border Forest Hills. Jackson, who named his farm Willow Glen after its array of weeping willow trees, ran a race track on the property that reportedly attracted prominent racehorse owner and *New York Ledger* editor Robert Bonner. The house is pictured here in 1927. (Courtesy of the Forest Hills Gardens Corporation.)

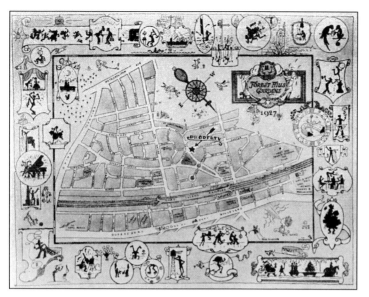

A 1927 map of Forest Hills Gardens, in the style of flapper-era artist John Held, is bordered by drawings that refer to community landmarks and noteworthy residents. Among the illustrations are an architect with an ornamental letter to honor Grosvenor Atterbury, and commuters running for a train, a reference to Station Square. A tennis racket serves as the south hand of the compass. (Courtesy of the Queens Historical Society.)

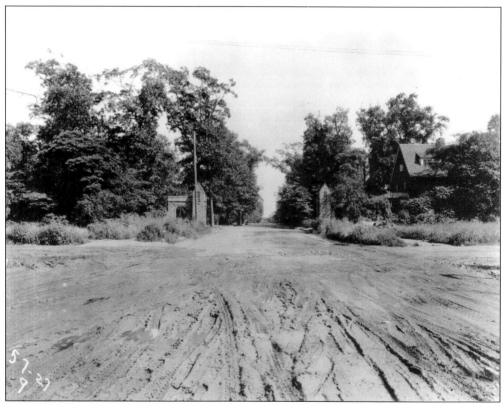

Brick gateways mark the Continental Avenue boundary of Forest Hills Gardens in 1927. Looking north from muddy Harrow Street, this picture shows chest-high weeds along the sidewalks outside the Gardens, contrasting with the manicured lawns of the private community. Developers soon started snatching up vacant plots south of the Gardens and built houses similar to the Tudor homes of Grosvenor Atterbury. (Courtesy of the Forest Hills Gardens Corporation.)

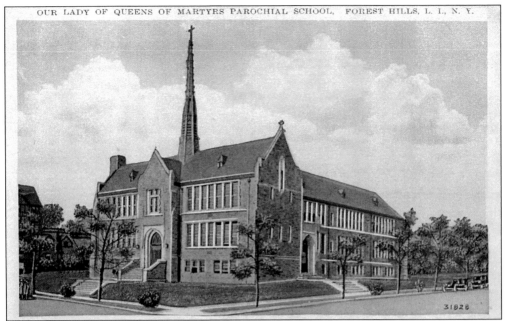

Ground was broken on January 5, 1928, for the new parish school of Our Lady Queen of Martyrs at Austin Street and Ascan Avenue. Designed by the Boston architectural firm Maginnis & Walsh, the school landed a first-place prize in 1929 for excellence in design and civic value from the Queensborough Chamber of Commerce. Classes were taught by the Sisters of the Immaculate Heart of Mary. (Courtesy of Bob Stonehill.)

A 1930 streetscape looking north on Union Turnpike from Austin Street shows the Kew-Forest School on the left and the Kew Kensington Court Apartments on the right. The widening of Union Turnpike would eliminate almost all of the school's spacious lawn. The year this photograph was taken, the Kew-Forest girls' basketball team went undefeated and clinched the championship at the Forest Hills Community House. (Courtesy of Queens Community Board 6.)

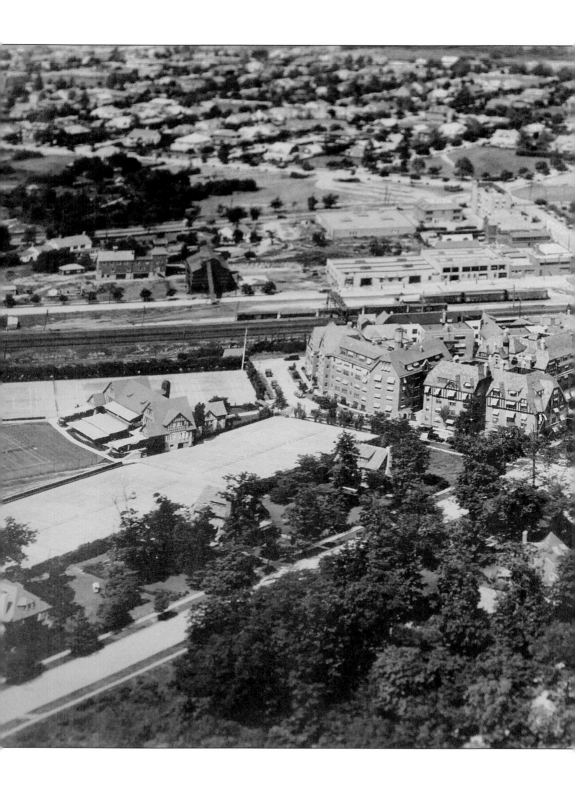

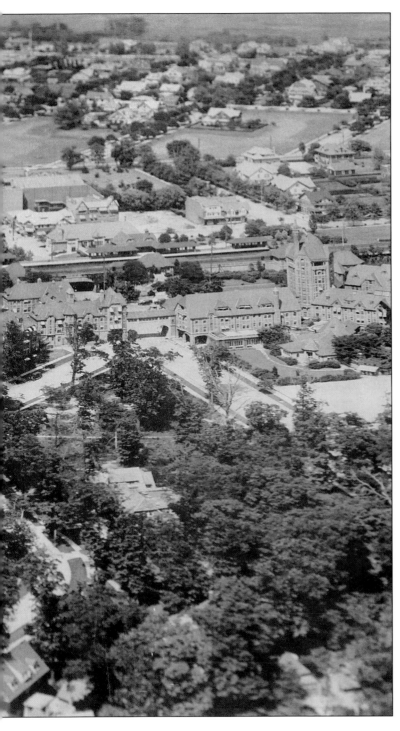

Many landmarks, including the Forest Hills Inn and the Forest Hills Theatre, are visible in this aerial photograph. Trees block most of the rooftops of Forest Hills Gardens, but an unobstructed view of northern Forest Hills showcases the clusters of homes north of 108th Street and the lack of development along much of Queens Boulevard. At the far left are the clubhouse and courts of the West Side Tennis Club, where an era ended in 1930. "Big Bill" Tilden, who dominated American tennis with seven national titles in the 1920s, was declining at age 37 and lost in the semifinals in Forest Hills to eventual champion John Doeg. Tilden would never again win a major tournament. Worse, his reputation evaporated in the 1940s after two arrests for homosexual encounters with minors. (Courtesy of Cord Meyer Development Company.)

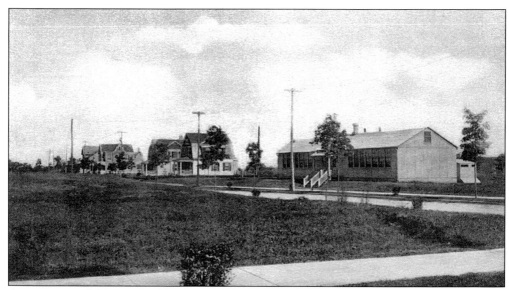

A microcosm of the growth of Forest Hills in the early 20th century, Public School 3 evolved from the one-story structure seen here, built in 1910, to the impressive building in the 1921 photograph below. In this image, the school stands on Seminole Avenue (modern 112th Street) between De Koven Street (Seventy-second Road) and Euclid Street (Seventy-second Avenue). It later moved to 108-55 Sixty-ninth Avenue. (Courtesy of Bob Stonehill.)

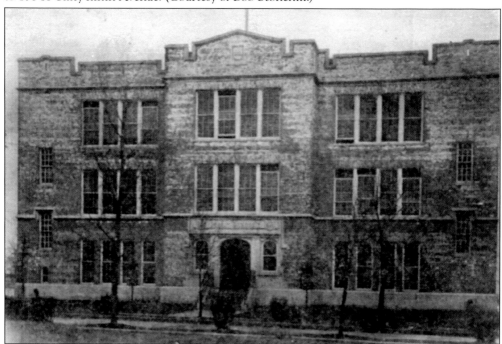

Public School 3, seen here on Sixty-ninth Avenue, hosted a bold speech on November 23, 1931. At a meeting of the Mothers' Club, E. Carleton Baker, the former American consul general in Manchuria, warned that American foreign policy in Asia rendered war with Japan "more certain." He also called Japan "our most likely adversary in the event of war." Baker's prophecy came true a decade later. (Courtesy of Bob Stonehill.)

A "For Rent" sign in a vacant storefront at 118-12 Queens Boulevard advertises "this excellent location at future subway station." An entrance to the Union Turnpike station would be placed in front of this building, whose second floor was rented by the Kew Forest Democratic Club. At left is the real estate office of Hendricks Barton Inc., and at right is the Colonial Garage. (Courtesy of Queens Community Board 6.)

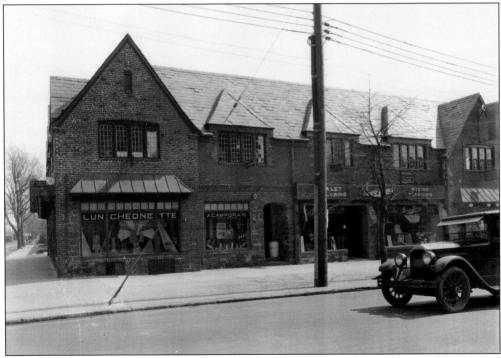

Businesses on the eastern side of Continental Avenue, including a corner luncheonette and Acampora's Drug Shops, are pictured in March 1930. At left is the intersection with Queens Boulevard. Behind the pole and tree at right is the Berger Service shop, where suits were "pressed and sponged" for 50¢. Signs on the block also advertise bowling and a dentist's office. (Courtesy of Queens Community Board 6.)

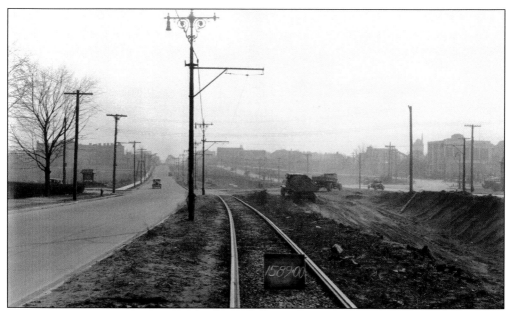

In March 1930, workers dig a subway tunnel to run beneath Queens Boulevard. Enamored by the promise of an affordable express route between Queens and Manhattan, developers constructed dozens of apartment buildings for commuters on Queens Boulevard between Forest Hills and Elmhurst. This view looks east toward Yellowstone Boulevard. The tower of the Forest Hills Inn can be seen in the distance at right. (Courtesy of Queens Community Board 6.)

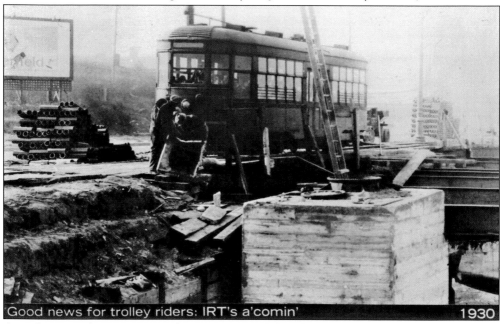

Good news for trolley riders: IRT's a'comin' 1930

As with most ambitious projects, the construction of the subway through Forest Hills encountered its share of setbacks. During a storm on July 3, 1930, so much rain poured into the excavation site at Continental Avenue that the shoring was washed away and the tracks caved in. The name of the Interborough Rapid Transit Company is abbreviated here, as it often was, to IRT. (Courtesy of Cord Meyer Development Company.)

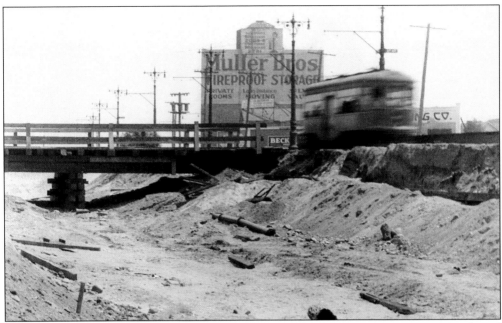

A temporary bridge at Sixty-seventh Avenue allowed pedestrians to cross Queens Boulevard during the subway's construction. In the background of this July 1930 photograph is a painted advertisement for the Muller Bros. fireproof storage warehouse at Queens Boulevard and Sixty-seventh Drive. A member of the National Furniture Warehousemen's Association, Muller Bros. offered vaults for valuables and shipping for local and long-distance moving. (Courtesy of Queens Community Board 6.)

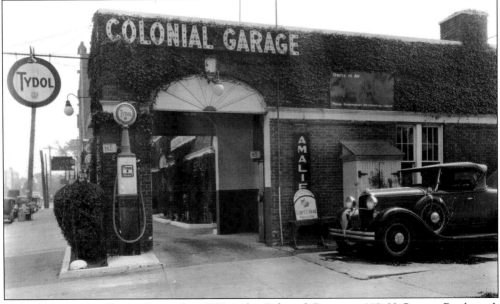

Gas sold for 21¢ a gallon in September 1930 at the Colonial Garage at 118-02 Queens Boulevard. Signs for oil companies, including Amalie and Hermoil, are plastered on the building and planted on the sidewalk. The garage's ivy-covered brick walls and fancy Tydol pumps are a sharp contrast to the bland designs of modern gas stations. (Courtesy of Queens Community Board 6.)

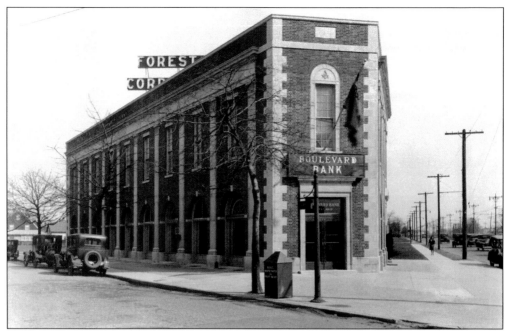

A flag hangs above the entrance to the Boulevard Bank at 108-01 Queens Boulevard in 1930. In the foreground is a trashcan designated for "waste paper and fruit skins." The building's facade hints at its other purpose as the Masonic Lodge of Forest Hills; above the corner window is the familiar Masonic symbol of a square and compasses accompanied by the letter G. (Courtesy of Queens Community Board 6.)

Tennis courts occupy the future site of Our Lady Queen of Martyrs Church in September 1930. To capitalize on the popularity of tennis in Forest Hills, a developer named his proposed six-story apartment building on Austin Street—near the parish school—after frequent champion "Big Bill" Tilden. The Tilden Arms, designed in Georgian Colonial style, was expected to cost $600,000 and accommodate 97 families. (Courtesy of Queens Community Board 6.)

The deed restrictions of Forest Hills Gardens came under attack in 1930, the year this photograph was taken of Archway Place. A nurse named Clarissa Sutherland planned to open a private sanatorium at 392 Burns Street, but residents insisted only homes were permissible in the private community. A judge in Brooklyn Supreme Court barred Sutherland from housing or treating patients at the premises. (Courtesy of Queens Community Board 6.)

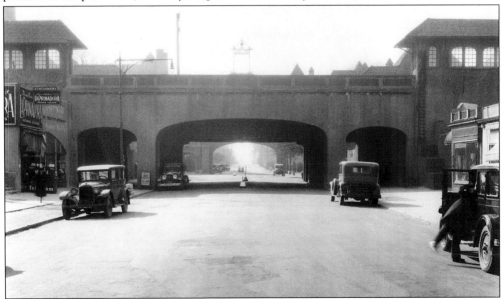

Continental Avenue proceeds south from Austin Street beneath the Long Island Rail Road viaduct in this photograph from February 19, 1932. At left are a shoe repair store and Max Schwarz's La Primadora Havana Cigars, which is selling copies of the *New York World-Telegram*. A real estate office sits on the right. (Courtesy of the Queens Borough Public Library Archives, Frederick J. Weber Photographs.)

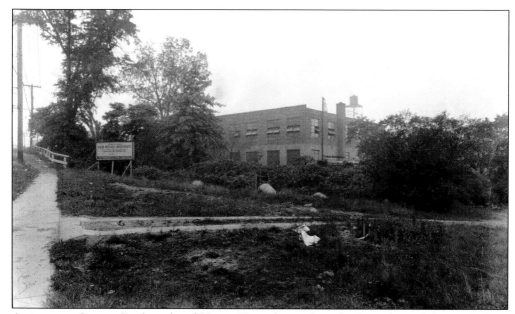

A sign near Queens Boulevard and Union Turnpike markets the "sound-proofed" Kew Bolmer Apartments, just over the eastern Forest Hills border at 80-45 Kew Gardens Road. The phone number that appears on the sign, Virginia 2441, also accompanied dozens of classified ads for apartments that were "completely furnished, including new studio, piano, [and an] all-night switchboard service." (Courtesy of Queens Community Board 6.)

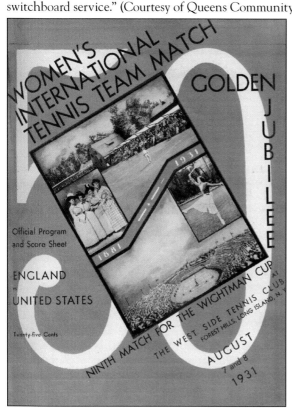

The West Side Tennis Club hosted the ninth match for the Wightman Cup in the summer of 1931. Eight years earlier, the Forest Hills stadium had debuted on August 10, 1923, with a Wightman Cup competition organized by the trophy's namesake, former champion Hazel Wightman. The inaugural contest pitted Helen Wills against Kathleen McKane. (Courtesy of St. John's University Libraries, William M. Fischer Collection, Queens, New York.)

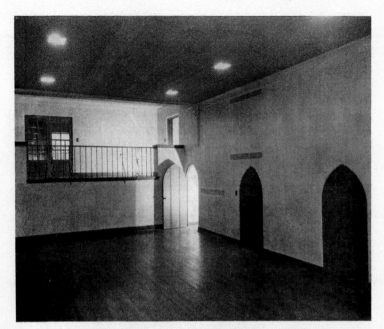

A Corner of the Beautifully Designed SQUASH COURT in the Basement

The Home of 1932

A Gentleman's Residence
in the Norman Manner
Forest Hills Gardens
Long Island

Built by the Builder who won the 1929 and 1930 prizes awarded by the Chamber of Commerce, in Queens, "for excellence in design and civic value".

Dubbed Norman Manner, this 14-room home at Greenway South and Slocum Crescent boasted so many amenities that its promotional brochure offered a grander label: "The Home of 1932." Its dining room was paneled in Louis XV style, typified by the high-caliber craftsmanship of 18th-century French cabinetmaking. The doors of the two-car garage were electrically operated. The photograph here shows the "beautifully designed" squash court in the basement. "We ask that you note this remarkable basement floor plan," the pamphlet read, "to meet the great American demand for exercise and entertainment." Its location in Forest Hills Gardens was only blocks from the West Side Tennis Club and about 14 minutes from Penn Station by Long Island Rail Road. What the brochure does not reveal, however, was the difficulty in attracting a buyer. In fact, an advertisement for the same home ran in the *New York Times* as early as August 1931 with its previous nickname, "The Home of 1931." (Courtesy of the Queens Historical Society.)

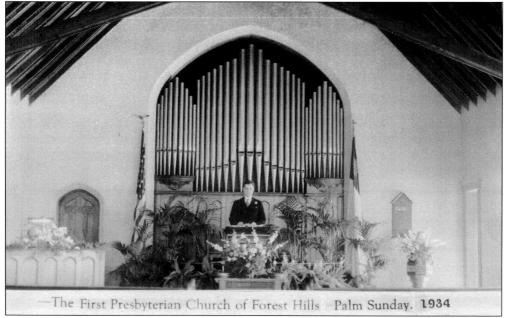

—The First Presbyterian Church of Forest Hills —Palm Sunday. 1934

The organ of the First Presbyterian Church of Forest Hills, previously known as the Union Church, is pictured on Palm Sunday, March 25, 1934. The church's pastor, the Rev. Elden Mills, delivered blunt sermons that called on his congregation to become more engaged in their faith. "Too many churchgoers," he said in 1932, "are like those who sit at a baseball game, fanning in the bleachers." (Courtesy of Bob Stonehill.)

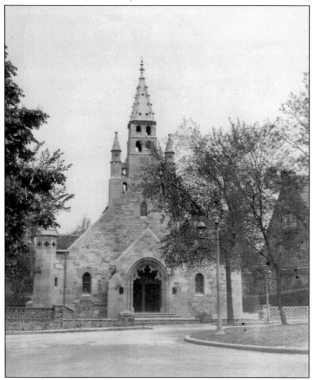

Opened in 1934 on Greenway Terrace, the First Church of Christ, Scientist, follows the teachings of the religion's founder, Mary Baker Eddy. After a fall on an icy sidewalk left her bedridden in 1866, Eddy read the Bible and suddenly recovered. She wrote a book on the science of Christ's healing methods, which became the basis for the church she established in 1879. (Courtesy of the Forest Hills Gardens Corporation.)

Three

DARK DAWN OF THE SUBWAY

Charles Vickery could not see far into the tunnel of blackness below Jackson Heights on December 30, 1936. Vickery, a motorman, was hesitant to hand over the controls of the train to an amateur, but he had little choice. Soon a funny-looking man entered the inspection cab, his chubby hands ready to steer the subway out of the Roosevelt Avenue station.

Fiorello La Guardia was beaming. Three years after he had been elected mayor of New York City, the pint-sized La Guardia was marking a landmark achievement: the first run of a new subway line that would connect central Queens to Manhattan. The 3.5-mile extension of the Independent Subway System would grant Forest Hills several stations, including an express stop at Continental Avenue and Queens Boulevard. In the short term, the new tracks would mean easier access between Forest Hills and the highly anticipated world's fair set to open in Flushing Meadows in 1939. Civic leaders focused more on the long-term impact. With the subway offering a cheap and quick commute, Forest Hills became a more desirable place to live. Developers were already planning apartment buildings to accommodate the expected influx of residents.

On the inaugural ride, the train rumbled from Jackson Heights to Kew Gardens in about 18 minutes, never stopping in Forest Hills. Then the train reversed its course. La Guardia and a gaggle of officials disembarked at Continental Avenue and headed to a celebratory luncheon at the Forest Hills Inn. Addressing the crowd of 300, La Guardia boasted that his economic plan for the city made possible the completion of the subway line. "For the first time," he said, "New York had the vision to look forward and plan for the future."

Before the day was done, George Harvey, the borough president of Queens, issued an astonishing prediction. The new subway branch would turn Queens Boulevard into "the Park Avenue of Queens," Harvey said, boldly referencing one of the most exclusive addresses in the country. In the generation to come, a wave of development would sweep across the boulevard, forever altering the landscape of Forest Hills.

As had happened near Continental Avenue, the opening of the Seventy-fifth Avenue subway station also encouraged the construction of apartment buildings that lured residents from midtown Manhattan. In this photograph, a sign for the Martel Manor on Seventy-sixth Avenue between Austin Street and Queens Boulevard invites passersby to inspect the "unusual layouts" of the rooms. These apartments were advertised elsewhere as "smart" and "modern." (Courtesy of Queens Community Board 6.)

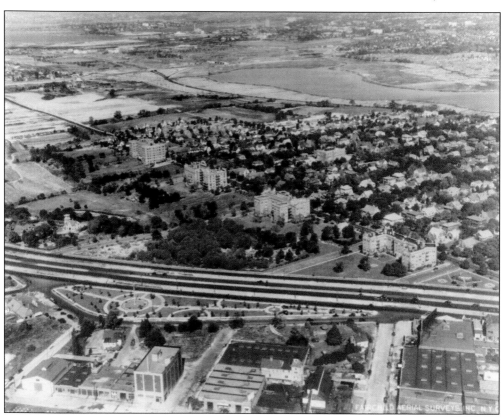

A 1937 aerial photograph demonstrates the proximity of Forest Hills to the open land in the north where the Corona ash dumps once stood. Infamous for heaps of garbage and manure, the dumps were cleared in preparation for the 1939 world's fair. The promise of millions of fairgoers pouring into Queens inspired developers to put up more apartments and commercial buildings in Forest Hills. (Courtesy of Queens Community Board 6.)

Our Lady of Mercy parish began in 1927 as the Chapel of the Little Flower, a mission church of Our Lady Queen of Martyrs, at Kessel Street and Continental Avenue. As the congregation grew, plans were finalized to replace the chapel with this Romanesque church, topped by an 85-foot belfry tower. Bishop Thomas Molloy officiated at the dedication Mass on September 26, 1937. (Courtesy of Diocese of Brooklyn Archives.)

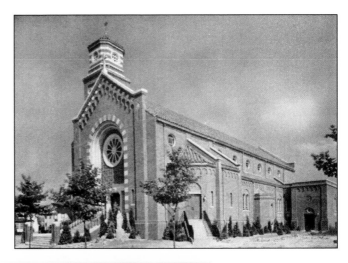

The modern interior of Our Lady of Mercy Church remains similar to its look in 1937. The ceiling of the sanctuary was painted red and spotted with gold Maltese crosses, while symbols of the Holy Eucharist and Christ's Passion appeared on its columns. Inlaid monograms of the Virgin Mary and St. Joseph adorned the side altars. In the basement was a spacious auditorium. (Courtesy of Diocese of Brooklyn Archives.)

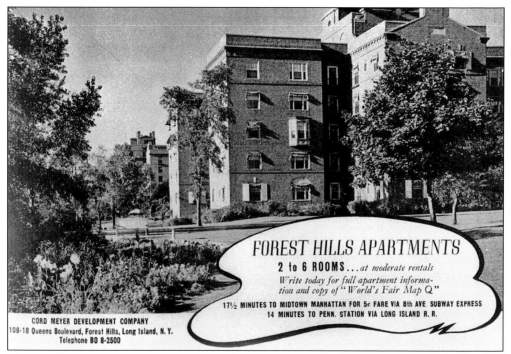

FOREST HILLS APARTMENTS

2 to 6 ROOMS...*at moderate rentals*
Write today for full apartment informa-
tion and copy of "World's Fair Map Q"

17½ MINUTES TO MIDTOWN MANHATTAN FOR 5¢ FARE VIA 8th AVE. SUBWAY EXPRESS
14 MINUTES TO PENN. STATION VIA LONG ISLAND R. R.

CORD MEYER DEVELOPMENT COMPANY
108-18 Queens Boulevard, Forest Hills, Long Island, N. Y.
Telephone BO 8-2500

This c. 1937 advertisement emphasizes the closeness of Forest Hills apartments to the impending 1939 world's fair at Flushing Meadows. Another ad by the Cord Meyer Development Company seemed to berate newspaper readers to "wake up and live in Forest Hills," calling it "one of America's finest home communities" with multiple shopping options and easy access to the subway. (Courtesy of the Queens Historical Society.)

Kensington Arms
64 - 45 BOOTH STREET
FOREST HILLS, L. I.

As the world's fair approached, advertisements for apartments in Forest Hills began promoting views of Flushing Meadows. This brochure for the Kensington Arms at 64-45 Booth Street boasted that its elevation on a hill offered terrific views of the fair's two symbols, the Trylon and Perisphere. The view would not last long, though. Both the 610-foot-tall Trylon and 180-foot-wide Perisphere were demolished after the fair. (Courtesy of the Queens Historical Society.)

Don Budge took the court at the West Side Tennis Club in 1938 after breezing through the Australian Open, the French Open, and Wimbledon. The slim Californian needed only a victory at Forest Hills to sweep all four major tournaments in a single calendar year. Before a gallery of 12,000, Budge beat Gene Mako, 6-3, 6-8, 6-2, 6-1, to complete the first grand slam in tennis history. (Author's collection.)

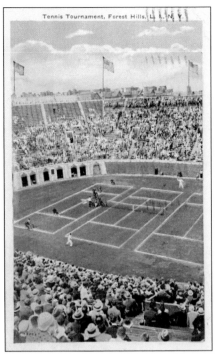

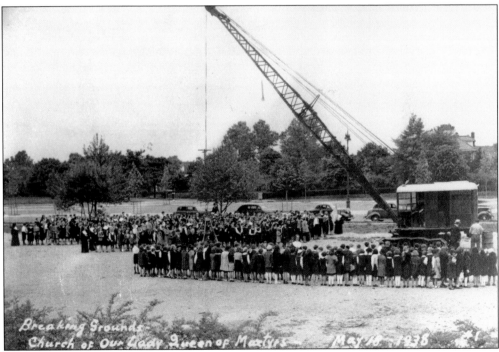

The Rev. Joseph McLaughlin broke ground on May 18, 1938, on Our Lady Queen of Martyrs Church at Ascan Avenue and Queens Boulevard. The parish's first pastor, McLaughlin set into motion the unified building plans for the school, church, and rectory. At the ground-breaking ceremony, he reportedly declined a speech in favor of four words to the excavator operator: "Now do your stuff." (Courtesy of Queens Community Board 6.)

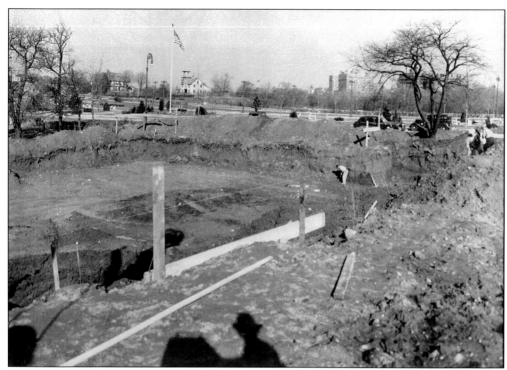

Construction continues in 1938 on the Forest Hills Post Office on the south side of Queens Boulevard at Seventieth Avenue. Its cornerstone, laid in 1937, bears the name of architect Lorimer Rich, who skyrocketed to fame a decade earlier when he collaborated on the winning entry in a competition to design the Tomb of the Unknown Soldier in Arlington National Cemetery. (Courtesy of Queens Community Board 6.)

Above the entrance to the Forest Hills post office, which was erected as a public works project during the Great Depression, floats this terra-cotta relief sculpture by Stockholm native Sten Jacobsson named "Spirit of Communication." Residents objected to the image of a topless woman holding a dove in one hand and a clock in the other, but it remained on the facade. (Courtesy of Queens Community Board 6.)

Dale Carnegie, who wrote one of the most successful self-help books of all time, lived in this home at 27 Wendover Road in Forest Hills Gardens. Carnegie achieved international fame in the late 1930s with the bestseller *How to Win Friends and Influence People*, in which he advised readers to avoid arguments, listen to others, and smile. He died at age 66 in 1955. (Courtesy of Queens Community Board 6.)

In this home at 45 Deepdene Road resided Lucy Allen Smart, best known for publishing a history of Forest Hills in 1924. Smart became the dean of the Kew-Forest School on Union Turnpike in 1941, capping a climb that began as assistant to the headmaster. After retiring in 1956, she moved to the Inn Apartments, where she lived until her death four years later. (Courtesy of Queens Community Board 6.)

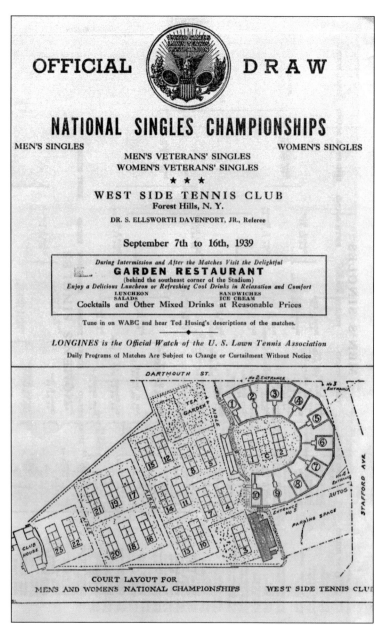

OFFICIAL DRAW

NATIONAL SINGLES CHAMPIONSHIPS

MEN'S SINGLES WOMEN'S SINGLES

MEN'S VETERANS' SINGLES
WOMEN'S VETERANS' SINGLES

★ ★ ★

WEST SIDE TENNIS CLUB
Forest Hills, N. Y.

DR. S. ELLSWORTH DAVENPORT, JR., Referee

September 7th to 16th, 1939

During Intermission and After the Matches Visit the Delightful
GARDEN RESTAURANT
(behind the southeast corner of the Stadium)
Enjoy a Delicious Luncheon or Refreshing Cool Drinks in Relaxation and Comfort
LUNCHEON SANDWICHES
SALADS ICE CREAM
Cocktails and Other Mixed Drinks at Reasonable Prices

Tune in on WABC and hear Ted Husing's descriptions of the matches.

LONGINES is the Official Watch of the U. S. Lawn Tennis Association

Daily Programs of Matches Are Subject to Change or Curtailment Without Notice

COURT LAYOUT FOR
MEN'S AND WOMEN'S NATIONAL CHAMPIONSHIPS WEST SIDE TENNIS CLUB

Days after Germany invaded Poland and provoked World War II, Bobby Riggs arrived at the West Side Tennis Club in search of his first Forest Hills championship. At age 21, Riggs did not boast the rocket serve of "Big Bill" Tilden or the powerful backhand of Don Budge, two of the most dominant players of the 1920s and 1930s. What Riggs did have, however, was a reputation as a remarkable strategist. He advanced to the finals with the types of lobs and drop shots that had won him Wimbledon a few months earlier. His final obstacle was the unranked Welby Van Horn, who dropped three straight sets, 6-4, 6-2, 6-4. Riggs faded from the spotlight for a few decades until 1973, when he played in so-called Battle of the Sexes matches against top-ranked women's players Margaret Court and Billie Jean King. This program from the 1939 championships entices fans to visit a restaurant near the stadium for "a delicious luncheon or refreshing cool drinks." (Courtesy of St. John's University Libraries, William M. Fischer Collection, Queens, New York.)

A 1930s pamphlet for the Grosvenor Square apartment building, named after architect Grosvenor Atterbury, brags of apartments with 5.5 rooms, three baths, and a dining alcove. A sentence inside summed up the benefits of the building at Burns Street and Ascan Avenue: "From the combined standpoint of design, construction, accommodations, locality, and orientation, this apartment dwelling should be classed as the finest in Queensboro." (Courtesy of the Queens Historical Society.)

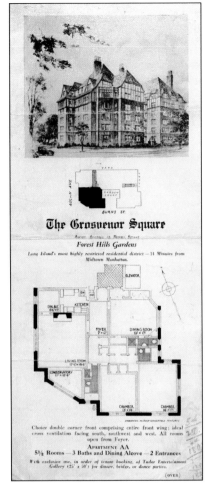

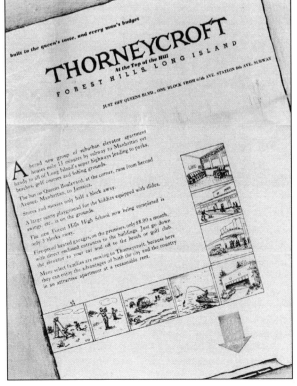

The slogan for the Thorneycroft Homes at Sixty-sixth Road and Ninety-ninth Street tops this flyer: "Built to the Queen's taste, and every man's budget." A four-room apartment with venetian blinds and a full-length mirror started at $71 a month. This c. 1939 handout appealed especially to families seeking "plenty of fresh air, lots of sunshine, and a view over landscaped acres." (Courtesy of the Queens Historical Society.)

The Klein farmhouse no longer fits in on Queens Boulevard by the late 1930s. Apartment buildings have sprouted around the Forest Hills home during a wave of development due to the subway extension and the 1939 world's fair. In the late 1950s, this site became the Diplomat apartment building, geared toward young families who were not ready to buy a private house. (Courtesy of Queens Community Board 6.)

The Hollis Diner listed its address as Forest Hills at the time of this c. 1939 postcard. Today, however, the site where it stood just north of the Long Island Expressway near Saultell Avenue is considered Corona. The diner claimed it lost much of its business during the expressway's construction. Note the spire of the Trylon from the world's fair in the background of the postcard. (Courtesy of Bob Stonehill.)

This Lease, made September 15, 19 39 . between

CORD MEYER DEVELOPMENT COMPANY, a domestic , hereinafter referred to as LANDLORD, and corporation at 108-18 Queens Blvd., Forest Hills, N. Y.

OTTO WINTERMEIER, 54-18 31st Avenue, Woodside, N. Y.
hereinafter referred to as TENANT,

Witnesseth, that the Landlord hereby leases to the Tenant, and the Tenant hereby hires and takes from the Landlord, his Store #9 in the building xxxxxx on the north side of , Queens Boulevard and 71st Road, Forest Hills, N. Y.

situated on xxxxxxxxxx in the Borough of Queens of The City of New York, for a term to commence as hereinafter stated 19 , and to end on December 31, 19 49 , unless sooner terminated as hereinafter provided, at the xxx Rent xx hereinafter fixed

payable as follows: TWO HUNDRED ($200) DOLLARS on the execution of this lease, which shall be the minimum rent for the first month of the term set forth herein. TWO HUNDRED ($200) DOLLARS as minimum rent for the second month of the term herein which shall be paid on the first day of the second month of the term of this lease, and a like amount on the first day of each and every month thereafter for the next seventy months, and a sum each month thereafter in accordance with paragraph thirty-two herein until the end of the term.

The tenant agrees that he shall pay a rental of 4% percent of the gross monthly sales, but in no event shall said rental be less than $ stated per month and said rental shall be payable on the first day of each and every month. The tenant agrees to keep above accurate books and other records of the business transacted, and of the sales effected by him on the demised premises, in such form and according to such system as the landlord may provide, and shall at all times, afford the landlord, its officers, agents and accountants, full and free access thereto. The tenant further agrees to furnish to the landlord at the end of each calendar month a statement of all sales effected during the month, on the form provided by the landlord. Any rent due on the basis of the 4% percent of the gross sales which is over and above the minimum rental of $ stated per month shall be ascertained at the end of each calendar month and paid to the landlord not later than the tenth of the following month.

It is expressly understood and agreed that the foregoing percentage of gross receipts and minimum rent are to be computed and paid on a monthly basis and that the lessee shall not be entitled to credit on any minimum monthly payment by reason of the fact that an excess over the minimum monthly rental has been paid in any preceding month.

The above letting is upon the following conditions, each and every one of which the Tenant covenants and agrees with the Landlord to keep and perform. It being agreed that the words "Landlord" and "Tenant" whenever used, include and bind, or benefit (as the case may be), the heirs, executors, administrators, successors, assigns, subtenants, occupants, servants, agents, and other representatives of the parties, as if each were specifically named.

FIRST: The Tenant will pay the rent and additional rent as above, provided.

SECOND: The Tenant will not sell, assign, or mortgage this lease, or any part thereof or of the term hereby granted, underlet the whole or any part of the premises, make any alterations therein, use or occupy all or any part thereof for any business or occupation other than that of Bakery and Pastry Shop

or for any purpose deemed extra hazardous on account of fire or otherwise; will not use any chemicals; will not place or permit or continue thereon any awning, projection, advertisement, sign, notice or device of any kind; cut or drill into, or disfigure the premises or the building or any part thereof, or permit it to be done by others; alter or obstruct or allow to be altered or obstructed the entrance to the building or the lights or skylights of the said premises; use or permit the use of

In Witness Whereof, the parties hereto have executed these presents the day and year first above written.

Executed as to the Landlord in the presence of

CORD MEYER DEVELOPMENT COMPANY

_____ ..L.S.
President.

Executed as to the Tenant in the presence of

_____ Otto WintermeierL.S.

GUARANTY

In consideration of the letting of the premises within mentioned to the Tenant within named, and of the sum of One Dollar, to the undersigned in hand paid by the Landlord within named, the undersigned hereby guarantees to the Landlord and to the heirs, successors and assigns of the Landlord, the payment by the Tenant of the rent, within provided for, and the performance by the Tenant of all of the provisions of the within lease. Notice of all defaults is waived, and consent is hereby given to all extensions of time that any Landlord may grant.

Dated, New York 19

...L.S.

STATE OF NEW YORK,
City of New York, } ss. :
County of

On this day of , 19 , before me personally appeared to me known and known to me to be the individual described in and who executed the foregoing instrument, and duly acknowledged to me that he executed the same.

With a few strokes of a pen, a bakery owner named Otto Wintermeier agreed to this 10-year lease with the Cord Meyer Development Company on September 15, 1939. His shop would not struggle for foot traffic. Its prime location on Queens Boulevard between Continental Avenue and Seventy-first Road drew commuters from the subway station on the very same block and residents of the apartment buildings popping up nearby. The lease locked in Wintermeier's rent over the first six years at $200 per month or four percent of his gross monthly sales, whichever was higher. Wintermeier also ceded to traditional restrictions that forbade him from subletting, erecting an awning, using chemicals, or operating the store as anything besides a bakery. By 2011, the stretch of stores that had once included Wintermeier's bakery housed a deli, a fruit store, a jeweler, a pharmacy, and a Key Food supermarket. All but the Key Food were evicted as Cord Meyer moved forward with plans for a high-rise residential building at the site. (Courtesy of Cord Meyer Development Company.)

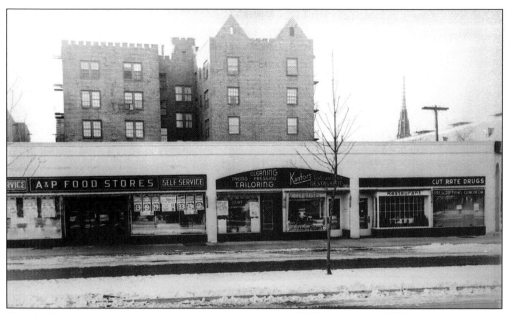

The slushy remnants of a snowstorm are apparent in this c. 1940 shot of an A&P food store, a cleaner, a deli, and a pharmacy on Queens Boulevard by Ascan Avenue. The per-pound prices advertised in the A&P windows were good deals even back then: 19¢ for loin pork chops, 25¢ for boneless beef brisket, and 33¢ for porterhouse steak. (Courtesy of Queens Community Board 6.)

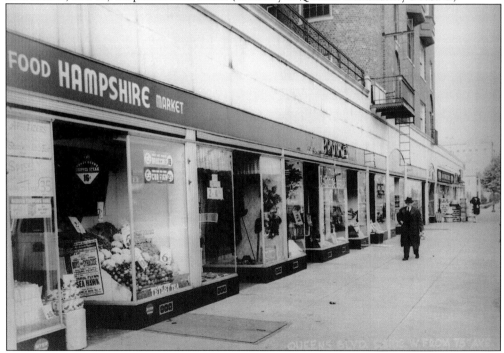

A few storefronts east of the businesses in the previous photograph, the Hampshire food market is seen in 1940 on the south side of Queens Boulevard. A poster in the window bills the Errol Flynn movie *The Sea Hawk* and Allan Jones and Martha Raye in the film *Boys from Syracuse*. Dresses are two for $11 at the store next door. (Courtesy of Queens Community Board 6.)

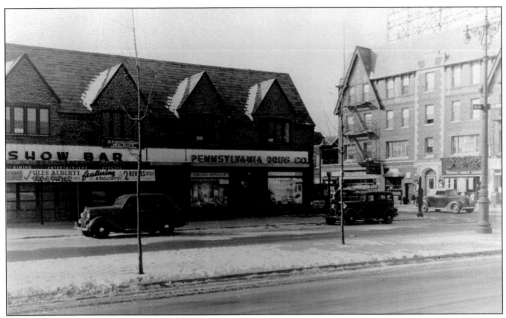

The Tap-a-Rhythm Orchestra played nightly in 1940 at the Show Bar on Queens Boulevard. Speaking here in 1936, Queens borough president George Harvey predicted the subway extension to Forest Hills would turn Queens Boulevard into "the Park Avenue of Queens." Across Continental Avenue in this photograph are Kent Cleaners, a corset shop, and a store selling meat and seafood. (Courtesy of the Forest Hills Gardens Corporation.)

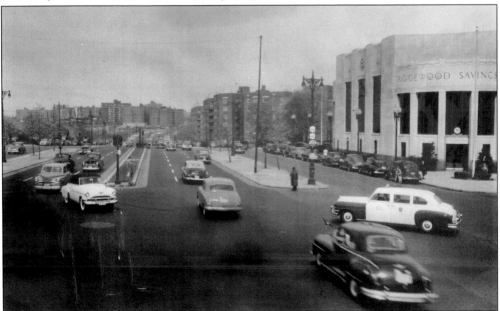

Traffic on Queens Boulevard passes the Ridgewood Savings Bank, constructed in 1939 and 1940. Designed in Modern Classical style by the architectural firm Halsey, McCormack & Helmer, the bank was built with bronze window grates, stylized eagles at the roofline, and limestone walls with flat, concave, and convex surfaces. An engraved lintel reading "Forest Hills Office" appears above the recessed steel-and-glass doors. (Courtesy of Cord Meyer Development Company.)

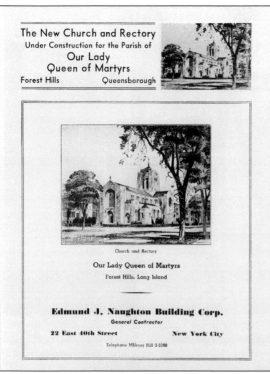

In keeping with the Gothic character of the parish school, the church for Our Lady Queen of Martyrs sports an exterior of seam-face granite with Indiana limestone trim. A crowd of about 3,000 attended its dedication on May 30, 1940, where Bishop Thomas Molloy said the church was significant as "the work of God-loving, God-fearing, and God-serving men and women." (Courtesy of Diocese of Brooklyn Archives.)

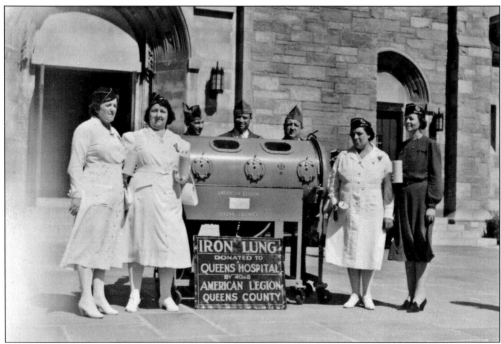

With Our Lady Queen of Martyrs Church as a backdrop, Queens members of the American Legion's Forty and Eight honor society donate an iron lung to a local hospital in 1940. The legionnaires had held a benefit at Carnegie Hall with performances by singer Beatrice Kay and songwriter Joe E. Howard to raise $6,000 for the ventilator. (Courtesy of the Forest Hills Gardens Corporation.)

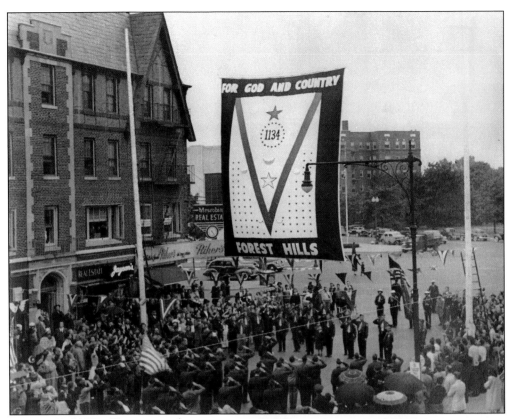

During World War II, a massive banner reading "For God and Country" hangs above a crowd at Continental Avenue and Queens Boulevard. At the corner is Riker's restaurant, whose signage includes the slogan "No Better Food at Any Price." Advertisements promised that its coffee with pure heavy cream would be "the best you ever drank." (Courtesy of the Forest Hills Gardens Corporation.)

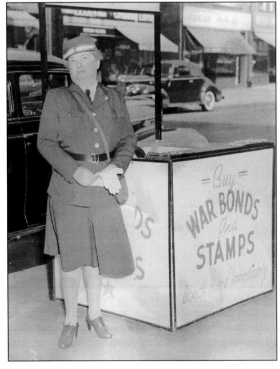

Booths like this one outside the Forest Hills Theatre sold bonds and stamps to finance World War II. Celebrities such as Bette Davis, Greer Garson, and Rita Hayworth toured the country to promote the bonds, and more than 185 million Americans bought them. (Courtesy of the Forest Hills Gardens Corporation.)

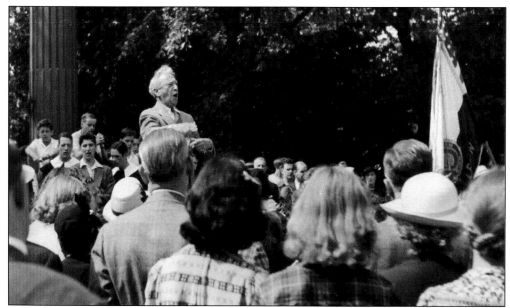

Shakespearean actor Albert Howson, a censorship director for Warner Bros. and the managing director of the Gardens Players, addresses a Memorial Day crowd at Flagpole Green. He operated a studio in the Gardens for "instruction in diction, dramatic art, public speaking, and the betterment and correct use of the vocal organ in speech," as the *Forest Hills Gardens Bulletin* put it. (Courtesy of the Forest Hills Gardens Corporation.)

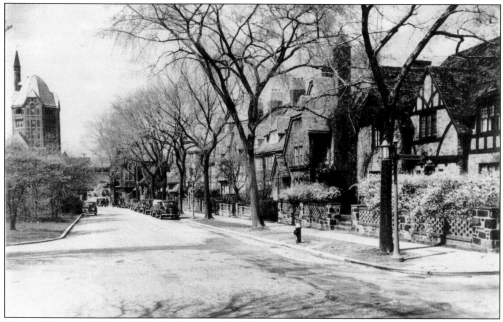

Tranquil scenes of Forest Hills Gardens, pictured here in 1940, motivated celebrities to move there. Among the prominent residents of the era were radio pioneer John Vincent Lawless Hogan, whose experimental radio station became WQXR; racehorse owner Hirsch Jacobs, who was inducted into the National Museum of Racing and Hall of Fame; and sculptor Adolph Alexander Weinman, who designed the Winged Liberty Head dime. (Courtesy of the Queens Historical Society.)

Drivers head westbound on Union Turnpike in 1940. A sign on a wooden pole at left, shaped like the Trylon and Perisphere from the world's fair, directs motorists to the fairgrounds in Flushing Meadows. At right, another sign points the way toward the Triborough Bridge, which connects Queens to the Bronx and Manhattan. (Courtesy of Queens Community Board 6.)

A view of Yellowstone Boulevard heading north from Sixty-seventh Road reveals patches of undeveloped land on February 21, 1941. Nine months later, a developer filed plans with the city for a six-story apartment building to be erected in the background of this photograph at 67-12 Yellowstone Boulevard. By 1954, a 4.5-room apartment there could be had for as little as $140 a month. (Courtesy of the Queens Historical Society.)

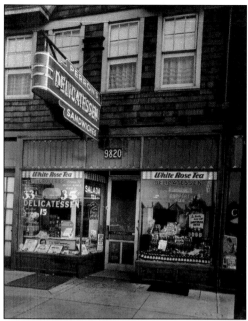

Eggs, butter, and beer are advertised in the windows of Perron's Delicatessen in 1940. The deli stood at 98-20 Metropolitan Avenue, opposite what would later become the parking lot for McDonald's. Its prices were enticing: 35¢ for a large pie and 15¢ for a chicken sandwich with Russian dressing and lettuce. (Courtesy of the Queens Borough Public Library Archives, Frederick J. Weber Photographs.)

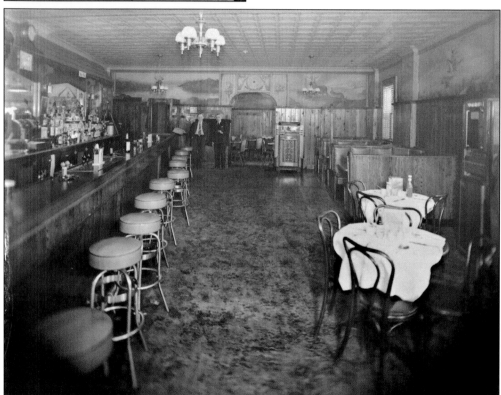

Before housing the Chalet Alpina restaurant, the building at 98-35 Metropolitan Avenue was once the G&G Forest Tavern. In this 1940 photograph, two men stand at the far end of the bar by a telephone booth and a mural depicting an elk. A sign behind them warns that dancing is forbidden. (Courtesy of the Queens Borough Public Library Archives, Frederick J. Weber Photographs.)

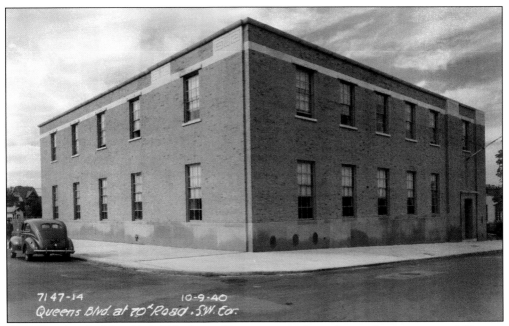

An office for the New York Telephone Company stands at the southwest corner of Queens Boulevard and Seventieth Road in 1940. A job listing for this office in 1968 sought clerks and typists to handle "a fascinating variety of assignments which put you in touch with all areas of telephone work." (Courtesy of the Queens Historical Society.)

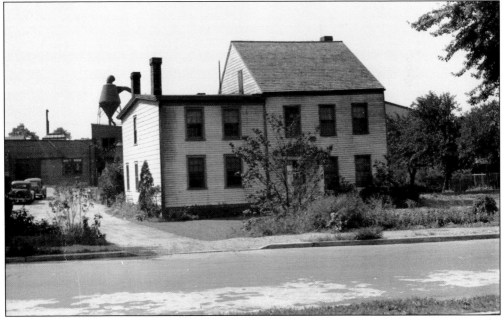

The Backus family home remained on Queens Boulevard into the 1940s, temporarily escaping the development that swept over Forest Hills in the wake of the subway's construction. A developer eventually gobbled up some of the Backus estate, however, and planned a shopping center on the north side of the boulevard between Sixty-ninth Avenue and Sixty-ninth Road. (Courtesy of Queens Community Board 6.)

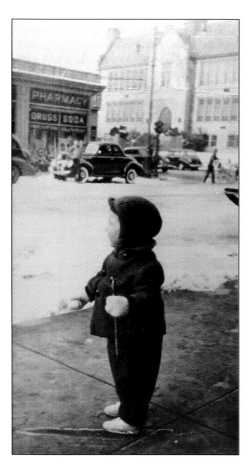

A bundled-up boy glances across snow-covered Ascan Avenue in 1941. In the background stand Lerner's Drug Store and the parish school of Our Lady Queen of Martyrs, both on Austin Street. Lerner's, which sold the popular Louis Sherry brand of ice cream, later became a Baskin-Robbins. (Courtesy of Queens Community Board 6.)

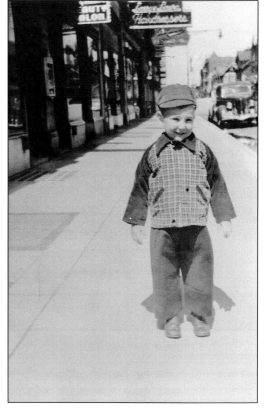

Above Austin Street hang signs for Larry & Laura Hairdressers and Brunn's Restaurant in this 1941 photograph. In 1935, an executive named John Carpenter ordered a drink at Brunn's, walked into the bathroom, and shot himself with a pistol. The jarred customers reported hearing what they thought was a door slamming. (Courtesy of Queens Community Board 6.)

A 1940s flyer for the Sussex Homes in the Cord Meyer section of Forest Hills promotes "the few remaining custom-built model homes in the finest residential community in New York City." Pictured at top left is a five-room house at 108-11 Sixty-sixth Road with a breakfast nook, a large terrace, and a price tag of $10,750. (Courtesy of the Queens Historical Society.)

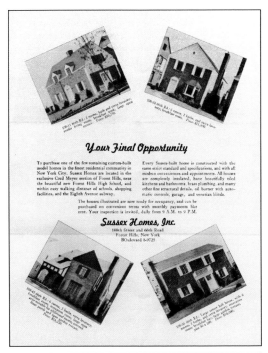

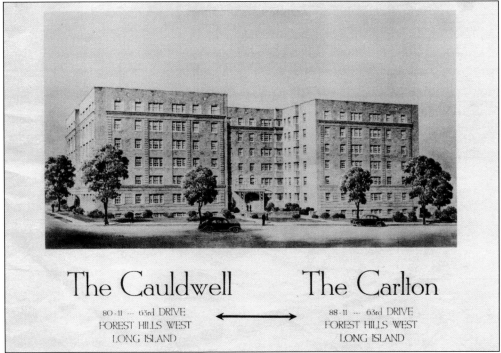

Located on Sixty-third Drive a few blocks off Woodhaven Boulevard, the Cauldwell and the Carlton apartment buildings were unique "both for their architectural beauty and the many unusual features they offer," according to this 1940s brochure. Handsome wallpaper and carpeted lobbies welcomed residents to the public halls, and most apartments had generous closet space and steel sink cabinets. (Courtesy of the Queens Historical Society.)

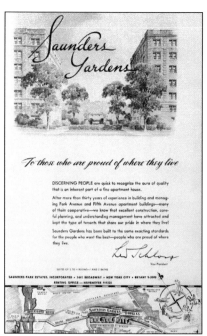

A map on this flyer for the Saunders Gardens apartments suggests a Forest Hills address. In fact, the site where these buildings rose at 62-45 and 62-95 Saunders Street is generally considered Rego Park. Drawings around the compass at the bottom show men swimming, riding on horseback, and playing golf and tennis. (Courtesy of the Queens Historical Society.)

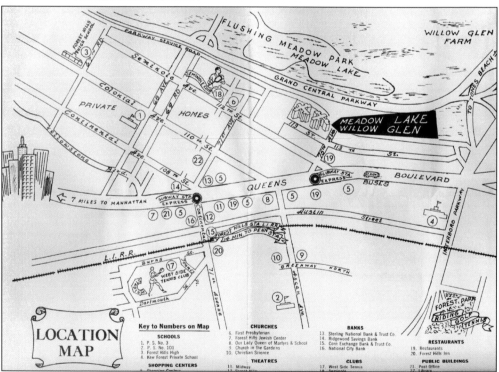

A bus zooms westbound on Queens Boulevard on this 1940s map that points out community landmarks such as Our Lady Queen of Martyrs Church and the Forest Hills Jewish Center on Queens Boulevard. To the north is a marker for the Seminole Club on Seminole Avenue (modern 112th Street), which hosted the New York State clay court tennis championships. (Courtesy of the Queens Historical Society.)

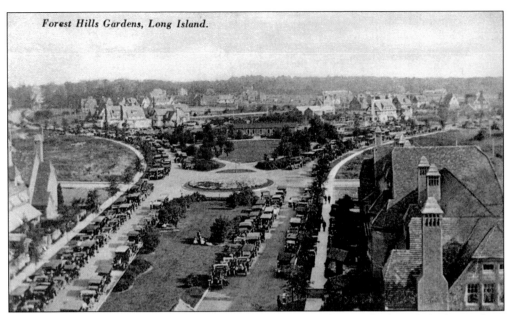

Forest Hills Gardens, Long Island.

For decades, stakeholders in Forest Hills Gardens butted heads over the fate of Block 12, where the office of the Sage Foundation Homes Company once stood. The foundation seemed especially protective of the site, seen at the top of this postcard, and repeatedly quashed proposals for single-family houses to round out the neighborhood. The land was eventually cleared for development by Robert Harriss. (Courtesy of Bob Stonehill.)

Robert Harriss developed this site at 150 Greenway Terrace, known as Block 12, into an apartment building named after his late brother, William Leslie Harriss. Early residents of the Leslie, which opened in 1943, included radio announcer Jimmy Wallington and Percy O'Connell, president of the American News Company, which distributed magazines and comic books. (Courtesy of the Forest Hills Gardens Corporation.)

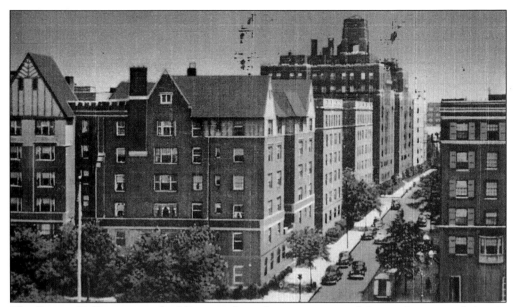

The Sutton Hall apartment building stands at the intersection of Ascan Avenue and Austin Street in this postcard. Promotional materials noted the old English Manor feel of the building, designed as "a triumph of comfort and hospitality." Kitchens were "scientifically planned to save steps and expedite the preparation of food." (Courtesy of Queens Community Board 6.)

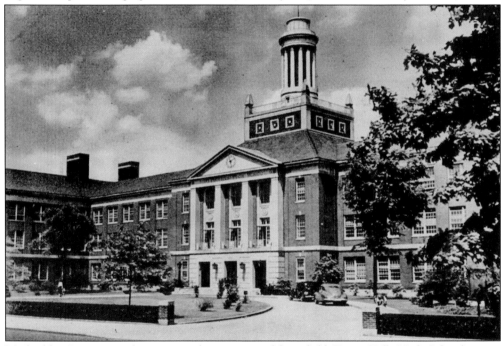

Marked by Georgian architecture and a spacious athletic field, Forest Hills High School was so grand that a high-ranking board of education official called it "the most beautiful educational structure in the city." Almost every aspect of the school fostered this assessment: its $2.25-million price tag, its redbrick walls with limestone trim, and its position on a promontory overlooking the 1939 world's fairgrounds. (Courtesy of Queens Community Board 6.)

Frederic Goudy, a renowned printer and typeface designer, ran the Village Press in Forest Hills Gardens with his wife, Bertha. His many fonts included the Deepdene series, an homage to his address. After his death in 1947, the *New York Times* wrote that Goudy "seemed to design type by instinct" and drew with an "elegance no man in modern times has excelled." The text of this book is set in Goudy Old Style, designed by Goudy in 1915. (Courtesy of the Forest Hills Gardens Corporation.)

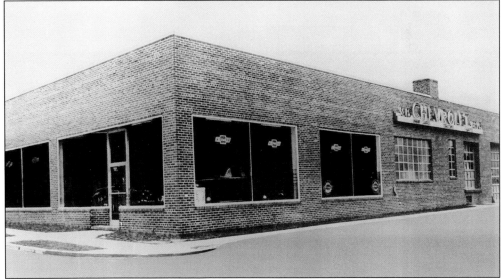

Construction was completed in 1948 on Northern Chevrolet, a garage, salesroom, and used car lot on Queens Boulevard at Sixty-ninth Avenue. When its owner, Peter Frischmann, died in 1953, the dealership was promptly sold to the Luby Realty Corporation and re-branded Luby Chevrolet. Early ads bore the slogan "I Love Luby," a reference to the similarly named TV show starring Lucille Ball. (Courtesy of Queens Community Board 6.)

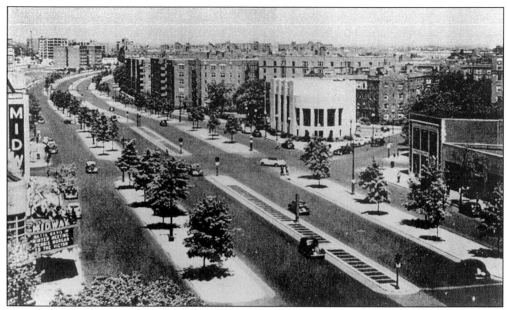

A 1948 view of Queens Boulevard looks west toward the Midway Theatre on the left and Ridgewood Savings Bank on the right. The theater, which opened on September 24, 1942, was named after Midway Island in the Pacific, the site of a major naval victory for the Allies in World War II. (Courtesy of Queens Community Board 6.)

Children in winter coats sing on the Station Square steps during a Christmas celebration in the 1950s. Some in the back are dressed as angels, shepherds, and wise men. On Christmas Eve 1950, Santa Claus distributed gifts to 75 children at the Brooklyn Home for Children on 112th Street, now the Forestdale Inc. foster care and child welfare agency. (Courtesy of the Forest Hills Gardens Corporation.)

Topsy's Cabin, a fixture for three decades at 112-01 Queens Boulevard, urged patrons to eat fried chicken and corn fritters with their fingers. Opened in Forest Hills on January 2, 1938, the chain restaurant had a logo depicting its namesake, a pigtailed slave from the classic 1852 novel *Uncle Tom's Cabin*. (Courtesy of Bob Stonehill.)

Inside Topsy's Cabin, an all-black wait staff served chicken and biscuits to customers beneath a mural that showed slaves on a Southern plantation. The menu also offered herring ice cream and a grilled Virginia ham steak with a pineapple ring and candied yams. Topsy's closed in the early 1970s, and the Pinnacle building later sprouted on the site. (Courtesy of Bob Stonehill.)

A 1950s matchbook for the Washerette at 104-10 Metropolitan Avenue promises "the fastest laundry in Forest Hills." Located between Seventy-first Drive and Seventy-second Avenue, the laundromat pledged to pick up dirty clothes by 12:00 p.m. and return them cleaned by 4:00 p.m. A graphic on the spine includes the slogan "End Washday Worries" hanging from a clothesline. (Author's collection.)

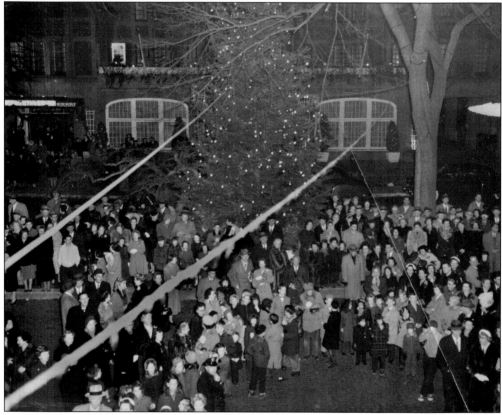

A Christmas tree glows during a 1952 celebration in Station Square. A few blocks away at Our Lady Queen of Martyrs Church, parishioners sang hymns every night during the Christmas season in front of an oil painting of the Nativity by local artist Richard Catan-Rose. (Courtesy of the Forest Hills Gardens Corporation.)

Frank Sedgman of Australia and San Diego native Maureen Connolly won the national singles titles at the West Side Tennis Club in 1952, the year this aerial photograph was taken. New York governor Thomas Dewey, four years removed from his surprising defeat to Harry S. Truman in the presidential election, caught some of the action from a box in the marquee. (Courtesy of Queens Community Board 6.)

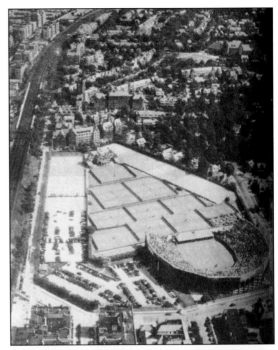

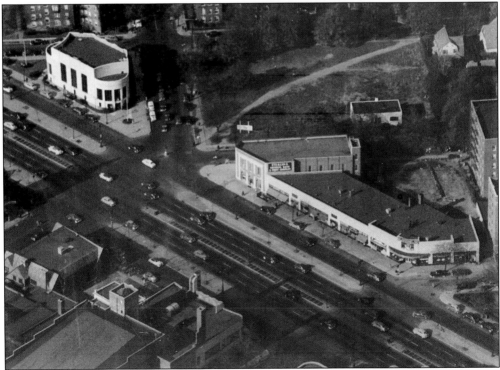

A 1953 aerial photograph shows the future site of the Forest Hills branch of the Queens Borough Public Library on Seventy-first Avenue north of Queens Boulevard. Mayor Robert Wagner laid the library's cornerstone on October 22, 1957, and returned for the dedication a year later on September 29, 1958. (Courtesy of Queens Community Board 6.)

During a children's parade through Forest Hills Gardens in 1955, two marchers mimic the dancing packs of Old Gold cigarettes that appeared in television commercials of the era. Their costumes include the precise text from the packs: "Made by Lorillard, a Famous Name in Tobacco for Nearly 200 Years." Other participants in the parade are dressed as clowns and cowboys. (Courtesy of the Forest Hills Gardens Corporation.)

This float, which drove through Forest Hills Gardens for a children's parade in 1955, was influenced by the nursery rhyme "There was an Old Woman Who Lived in a Shoe." The rhyme dates to the 18th century, but it reached a new generation in 1948 when referenced in the best-selling book *Cheaper by the Dozen*. (Courtesy of the Forest Hills Gardens Corporation.)

A 1957 photograph of the Forest Hills High School basketball team shows future New York State assemblyman Alan Hevesi in the top row, fourth from the right. Hevesi served as the comptroller of New York City from 1994 to 2002 and was elected state comptroller in 2002, but he resigned four years later amid a scandal in which he admitted to defrauding the government. (Courtesy of Queens Community Board 6.)

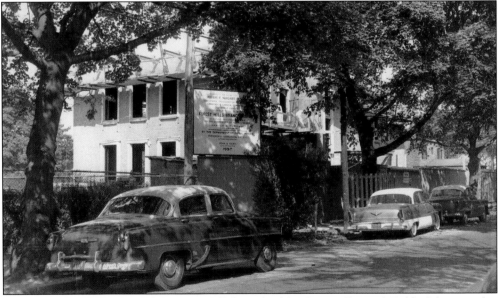

Construction is underway on the Forest Hills branch of the Queens Borough Public Library in this 1957 photograph. The two-story library of brick and limestone was designed by the architectural firm Boak & Raad, which had also planned the high-rise Park Gramercy apartment building in Manhattan on the site where industrialist Peter Cooper once lived. The cost of construction, equipment, and books exceeded $600,000. (Courtesy of Queens Community Board 6.)

GERALD NORMAN SPRINGER
Senior Band

Tabloid talk show host Jerry Springer graduated in 1961 from Forest Hills High School, where he was a member of the senior band. Other famous faces to attend Forest Hills High include Paul Simon and Art Garfunkel, the original members of the punk rock group the Ramones, and Jack Lew, the chief of staff to Pres. Barack Obama. (Courtesy of Queens Community Board 6.)

In the 1960s, the restaurant at the Forest Hills Inn changed its name. Previously known as the Unicorn Lounge and Bar, the eatery became The Three Swans and booked a young Barry Manilow to play piano. The space later became Beefsteak Charlie's and the Melting Pot, which served fondue. Jade Eatery & Lounge opened there in 2006. (Courtesy of the Queens Historical Society.)

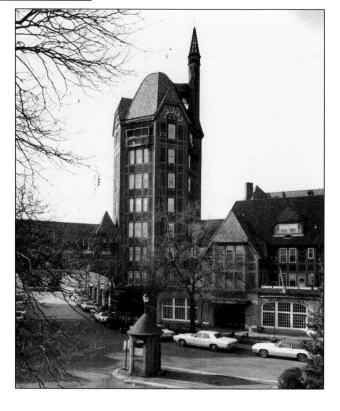

Four

BROILING OVER PUBLIC HOUSING

The suburban peace of Forest Hills was shattered in 1966 by three words that stirred up more bile than the neighborhood had ever seen. John Lindsay, the mayor of New York City, used the term "scatter site housing" to proffer his vision to eliminate ghettos by relocating the poor to projects in middle-class, white neighborhoods. For his first attempt, Lindsay targeted an area on the northern edge of Forest Hills, on Sixty-second Drive near the Long Island Expressway. It was almost Corona, but residents still viewed it as an attack on Forest Hills.

The ethnic and racial dynamics of the controversy were tantalizing. One of the project's most vocal detractors, Dr. Alvin Lashinsky of the Queens Jewish Community Council, described the debate as pitting "middle class versus low income." Sociologists could not help but notice the irony of Jews, famously persecuted and driven out of so many lands, leading violent protests to keep out impoverished blacks and Puerto Ricans from the neighborhood. As television news crews disseminated the rallies to audiences across the country, the public housing war threatened to supplant the US Open as the claim to fame for Forest Hills.

Under a compromise brokered by a rising lawyer named Mario Cuomo, the Forest Hills project morphed from three buildings of 24 stories each, with 840 low-income apartments mostly for minorities, to three buildings of only 12 stories each, with 430 low-income apartments, about half of them allotted to the elderly and veterans. But the venom did not end even when Lindsay left office in 1973. After Abe Beame became the first practicing Jew to be elected mayor, protesters circulated flyers demanding that Beame face a rabbinical court to answer for his "lack of action responsible for the destruction of Forest Hills." Another handout urged residents to attend a 1975 meeting at Forest Hills High School that would center on a series of troubling questions: "What threatens our senior citizens? Our merchants? Our younger children? YOU?"

Forest Hills had come so far. And some feared the tranquility they found there would vanish in a parade of moving trucks.

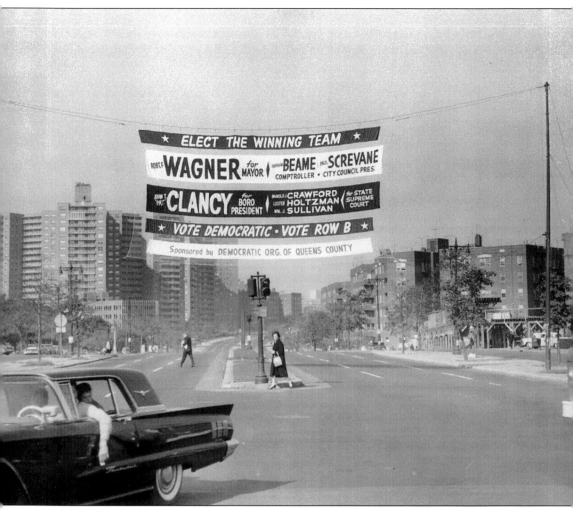

Large political banners hang over Queens Boulevard at Continental Avenue to promote Democratic candidates in the 1961 elections. Mayor Robert Wagner's reelection campaign receives top billing on the same white banner that advocates for Abe Beame for city comptroller and Paul Screvane for city council president. During a stop in Forest Hills in August, Wagner opened a campaign office at Queens Boulevard and Union Turnpike and met with constituents who complained about overcrowded trains at the Continental Avenue subway station and a lack of benches in MacDonald Park. Wagner defeated the party-backed candidate, New York State comptroller Arthur Levitt, in the primary in September, and he trounced his Republican challenger, New York State attorney general Louis Lefkowitz, in the November general election. The other banners here urge voters to cast ballots for John "Pat" Clancy for Queens borough president and Harold Crawford, Lester Holtzman, and William Sullivan for the state supreme court. (Courtesy of the La Guardia and Wagner Archives, La Guardia Community College/The City University of New York.)

No subject generated more controversy in Forest Hills in the 1960s and 1970s than the proposal for a low-income housing project at 108th Street and Sixty-second Drive. This c. 1965 rendering shows one of three planned 24-story buildings that drew ire from the community. (Courtesy of the New York City Housing Authority and the La Guardia and Wagner Archives, La Guardia Community College/The City University of New York.)

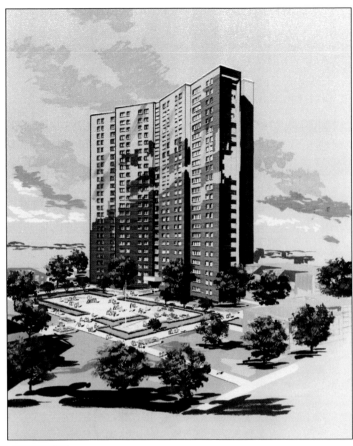

The Forest Hills Inn underwent its first major interior renovation in the mid-1960s, marking a shift from hotel rooms to apartments. The Inn's new owner, Mark Fleischman, charged $175 to $180 a month for two-room units and $240 to $250 for apartments with three rooms. Fleischman also imported furniture from London and created a "Celebrity Walk" with handprints and footprints on the sidewalk outside the Inn. (Author's collection.)

The Guide Dog Foundation for the Blind, which provides trained Golden Retrievers and Labrador Retrievers for free, was long headquartered in Forest Hills. It now operates on an eight-acre campus in Smithtown, Long Island, where the blind spend 25 days in a training program that includes complimentary room and board. (Courtesy of Bob Stonehill.)

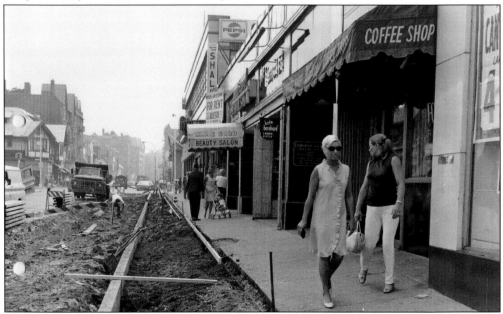

Roadwork does not interrupt shopping on Austin Street on September 17, 1968. Pedestrians pass by the Christian Science Reading Room, the Kate Bernhard gift shop, and the Marie Gurd beauty salon, whose address was incorrectly listed as Boston Street in a 1980 job listing in the *New York Times*. Beyond the Marie Gurd awning is a sign for the Cameo bowling alley. (Courtesy of Queens Community Board 6.)

Little traffic drives past Luby Chevrolet in this 1968 view looking west on Austin Street from Sixty-ninth Road. Beyond Luby is a Texaco station, and across the street are the Luby body shop and Floyd E. Rosini & Sons Furniture. The latter was renamed Rosini Service LTD two years later, and it now operates as Rosini Furniture Service out of Mineola, Long Island. (Courtesy of Queens Community Board 6.)

Trucks for Levy's bread and the Bohack supermarket chain rumble along Austin Street in September 1968. On the north side of the street are Sonia Suits & Dresses and Gulf and Shell gas stations. In the distance at left, the Continental movie theater screens the French film *The Bride Wore Black*, starring Jeanne Moreau as a widow seeking revenge on her husband's killers. (Courtesy of Queens Community Board 6.)

The Continental movie theater, seen here in 1968, debuted on Austin Street five years prior. A 1963 advertisement played up the theater's attributes: "From the beautifully decored lounge you can either step down to the orchestra level—or easily make your way up to the mezzanine. Here is a truly refreshing entree into the experience of movie-going—a relief from the conventional that delights the eye and satisfies the desire for originality. And here too, you'll find the traffic moves so well—you reach your seat so quickly and conveniently, with never a sense of a crowd." The Continental's first screening was the film adaptation of Jean Genet's play *The Balcony*. In the movie, Shelley Winters plays a madam who oversees the rendezvous between her gorgeous employees and well-to-do customers like the local police chief (Peter Falk). (Courtesy of Queens Community Board 6.)

A small commercial strip on Yellowstone Boulevard between Juno and Ingram Streets is occupied by Yellowstone Pharmacy, a TV repair store, a laundromat, a Key Food supermarket, Dori's Lounge, and a deli on October 2, 1968. Posters in the Key Food windows advertise sales on biscuits, steaks, sugar, and coffee. (Courtesy of Queens Community Board 6.)

Celebrity chef Lidia Bastianich opened her first restaurant, Buonavia, with her husband, Felix, on Queens Boulevard in 1971. In her 2001 book *Lidia's Italian-American Kitchen*, Bastianich recalled how Buonavia—which means "on the good road" in Italian—served gnocchi, polenta, risotto, and a scampi appetizer that made the eatery "wildly popular." The couple sold Buonavia in 1981, and Bastianich went on to host Italian cooking shows on PBS. (Author's collection.)

On May 17, 1972, Mayor John Lindsay appointed lawyer Mario Cuomo, pictured here, to mediate the fiery dispute over a proposed housing project in Forest Hills. In the months that followed, Cuomo kept a detailed journal that would become the book *Forest Hills Diary: The Crisis of Low-Income Housing*. Cuomo's knack for compromise raised his profile, and he was elected governor in 1982. (Courtesy of Queens Community Board 6.)

From its perch above a Gristede's supermarket on Austin Street, the Queens County Democratic Committee reviewed the records of several mayoral candidates in 1973. On May 10, the committee switched its endorsement from scandal-scarred Bronx congressman Mario Biaggi to comptroller Abe Beame, who was elected mayor. (Courtesy of the La Guardia and Wagner Archives, La Guardia Community College/The City University of New York.)

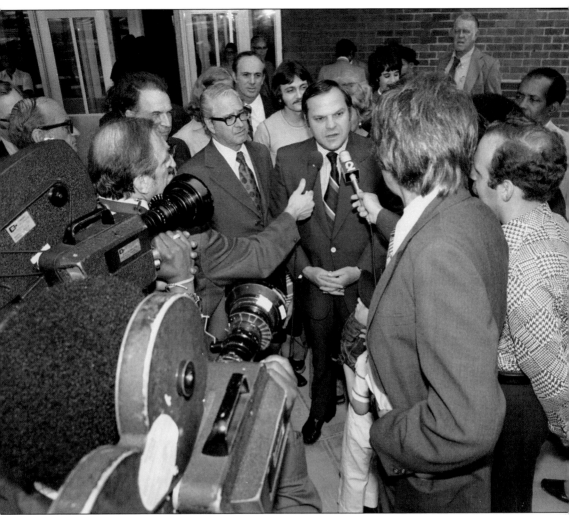

Television news crews descend upon Queens borough president Donald Manes on July 1, 1975, as the controversial Forest Hills housing project welcomes its first wave of occupants. Lawyer Mario Cuomo, who had been appointed to mediate the controversy, wrote in his journal that Forest Hills residents had a deeply ingrained fear of the crime associated with housing projects: "I'm inclined to think that no matter what statistics and evidence we're able to marshal, this community's fear will not be totally dissipated. One story of a mugging at a project—whether or not true—will overcome in their minds any array of statistics." Eleven years later, Manes resigned the borough presidency while embroiled in a corruption scandal. At his home in Jamaica Estates on March 13, 1986, he committed suicide by stabbing himself in the heart with a kitchen knife. (Courtesy of the New York City Housing Authority and the La Guardia and Wagner Archives, La Guardia Community College/The City University of New York.)

In the bicentennial year of 1976, Uncle Sam and the Liberty Bell adorn a sixth-grade class composite picture from Public School 144. Comedian Ray Romano, who grew up in Forest Hills, said in an interview that he often played softball in the schoolyard: "The left-field fence was the perfect distance and height to justify it being a home run if you hit it over." (Courtesy of Brian Sturm.)

Mayor Abe Beame and his wife, Mary, attend a match at the West Side Tennis Club in 1976. In November, Beame announced that a World Team Tennis club named the New York Sets was negotiating to play two games the following season at Forest Hills. (Courtesy of the La Guardia and Wagner Archives, La Guardia Community College/The City University of New York.)

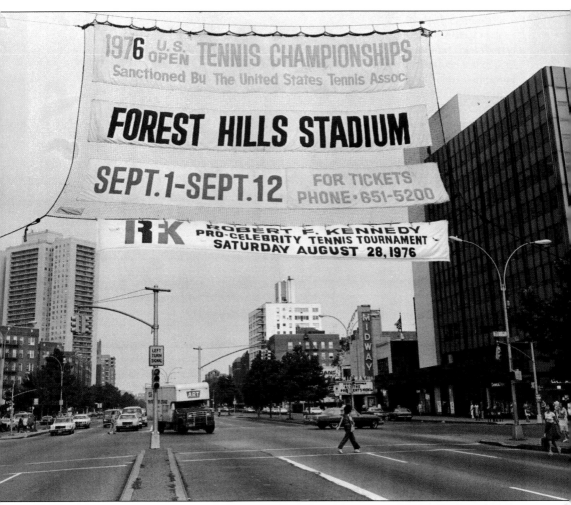

Banners flap in the wind above Queens Boulevard in 1976 to advertise the US Open and a celebrity tennis tournament, both at the West Side Tennis Club. First came the celebrity tourney, which was named after the late senator Robert F. Kennedy and raised money for underprivileged youth. The Kennedy family turned out in force, including the senator's widow, Ethel, his brother, Sen. Ted Kennedy, and his sister-in-law, former first lady Jacqueline Kennedy Onassis. So did a wide array of celebrity "hackers galore," as the *New York Times* put it. Football star O.J. Simpson lacked hand-eye coordination on the court, the *Times* reported, while former NBA All-Stars Bill Bradley and Dave DeBusschere plunged futilely for the ball. Also in attendance were actress Lauren Bacall, composer Burt Bacharach, comedian Buddy Hackett, and singer Andy Williams. Forest Hills, however, would not remain in the limelight much longer. Growing concerns about outmoded facilities and insufficient parking led the United States Tennis Association to move the Open to Flushing Meadows in 1978. (Courtesy of the Queens Borough Public Library Archives, Joseph A. Ullman Photographs.)

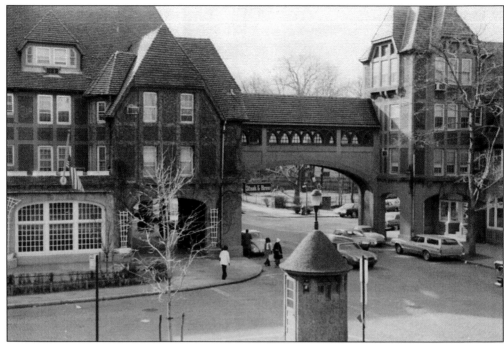

A Steak & Brew restaurant, seen in the 1970s, drew customers hungry for booze, burgers, and ribs to the Forest Hills Inn. To court tennis fans dismayed by food prices at the 1974 US Open, Steak & Brew lowered the cost of its drinks to $1 between 2:00 p.m. and 4:30 p.m. A restaurant manager said that sales picked up 20 percent during the tournament. (Courtesy of Brian Sturm.)

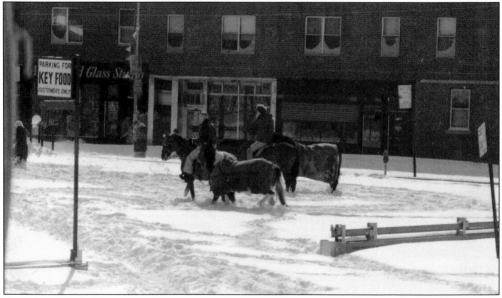

Horses trudge through heavy snow on Metropolitan Avenue in the late 1970s or early 1980s. Imparting a rural look to Forest Hills, horses from Dixie Dew Stables and Lynne's Riding School often clopped from Seventieth Road onto Sybilla Street, turned right onto Seventy-first Avenue, and crossed Union Turnpike into Forest Park. At left in this photograph is a sign for the Key Food parking lot. (Courtesy of Christopher Orlando.)

Vice Pres. Walter Mondale (left) campaigns in Forest Hills with the Democratic mayoral candidate, Congressman Ed Koch, on October 13, 1977. Speaking to a crowd of 350 at the Stratton Restaurant on Queens Boulevard, Mondale said he "strongly, enthusiastically, and joyously" supported Koch. In November, Koch defeated the Liberal Party's Mario Cuomo to become New York's 105th mayor. (Courtesy of the Queens Borough Public Library Archives, Joseph A. Ullman Photographs.)

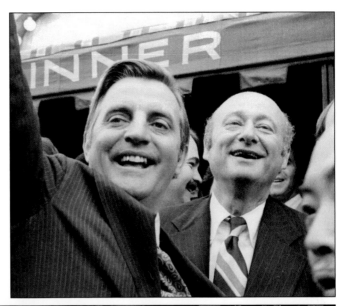

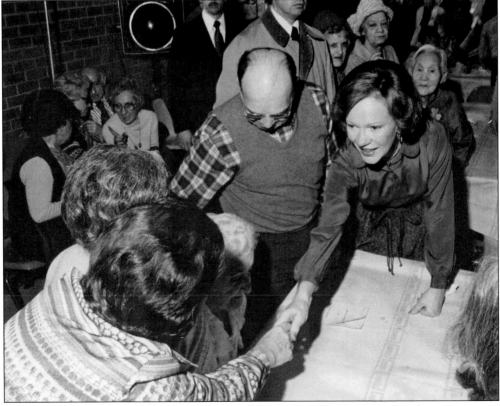

During a visit to a Forest Hills senior center on March 13, 1980, First Lady Rosalynn Carter was greeted by cheers and jeers. She said her husband's commitment to Israel was "deep," but a group that viewed the president's policies as anti-Semitic picketed outside the building. (Courtesy of the New York City Housing Authority and the La Guardia and Wagner Archives, La Guardia Community College/The City University of New York.)

Crowds await a glimpse of Pres. Jimmy Carter as his motorcade drives down Austin Street on October 13, 1980. Despite the mixed reaction the first lady received in Forest Hills in March, Carter planned a stop in the neighborhood to court Jewish voters. As he entered the Forest Hills Jewish Center on Queens Boulevard, protesters booed and taunted him with signs criticizing his policies on Israel. (Courtesy of Brian Sturm.)

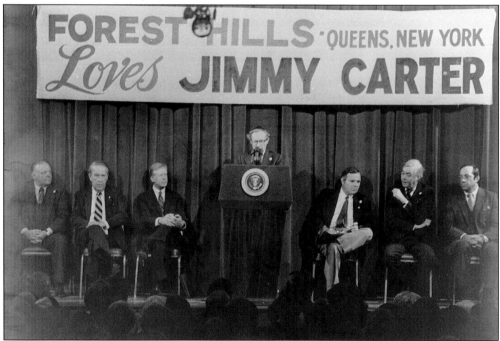

Contrary to the banner, Forest Hills did not show much love to Jimmy Carter on October 13, 1980. Hecklers frequently interrupted the president's speech at the Forest Hills Jewish Center with cries of "Jerusalem is Jewish." Seated on the dais are, from left to right, Congressman Joseph Addabbo, Sen. Henry "Scoop" Jackson, Carter, Queens borough president Donald Manes, Sen. Daniel Patrick Moynihan, and Lt. Gov. Mario Cuomo. (Courtesy of Queens Community Board 6.)

A fire truck from Engine Company 305 parks on Queens Boulevard in front of Mr. Sleep Bedding Centers, whose sign promises "quality-name brands at low prices." A poster in the window promotes a deal for a mattress and a box spring at $100. Next door, the Italian restaurant Fontana di Roma served hot antipasto and fettuccine Alfredo. (Courtesy of Brian Sturm.)

American flags hang from utility poles on Metropolitan Avenue during a Memorial Day parade in the early 1980s. The parade ends each year with the laying of wreaths on the graves of Revolutionary War colonel Jeromus Remsen and his family in a cemetery at Alderton Street and Trotting Course Lane. A schools complex was later built where the lumberyard is pictured here. (Courtesy of Brian Sturm.)

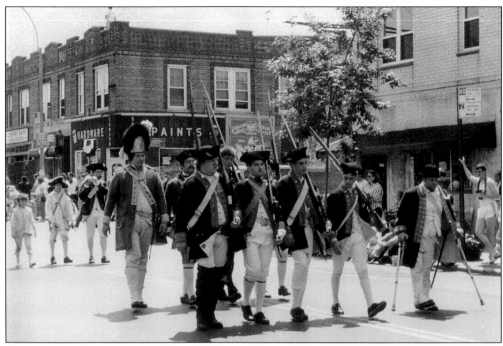

Men in replica Revolutionary War uniforms march in a Memorial Day parade down Metropolitan Avenue in the early 1980s. Visible in the background are C. Henry Smith Real Estate, Samson Hardware, and a small billboard for the Ringling Bros. and Barnum & Bailey Circus. A man on the roof of a building at Sixty-ninth Road looks east toward Seventieth Avenue. (Courtesy of Brian Sturm.)

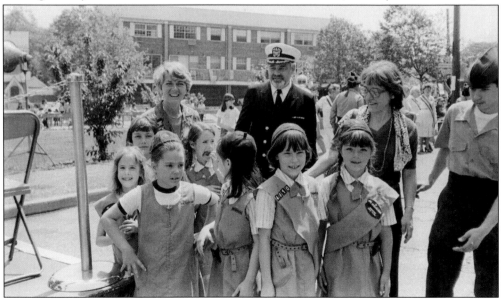

Congresswoman Geraldine Ferraro poses for a photograph with Girl Scouts at the end of the Memorial Day parade on May 25, 1981. Ferraro, who lived at 22 Deepdene Road in Forest Hills Gardens, became the first woman to run on the national ticket of a major party when Walter Mondale selected her as his running mate in 1984. (Courtesy of the Queens Borough Public Library Archives, Joseph A. Ullman Photographs.)

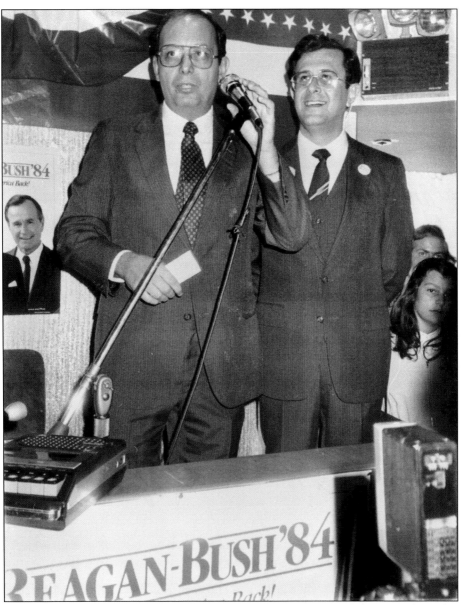

A month before the 1984 presidential election, Sen. Al D'Amato speaks on October 7 at the opening of the Ronald Reagan campaign headquarters at 112-01 Queens Boulevard, the former address of the Topsy's Cabin restaurant. Reagan enjoyed strong support in Forest Hills even though the opposing Democratic ticket included vice presidential candidate Geraldine Ferraro, who lived in Forest Hills Gardens and represented the area in Congress. Paul Klotz found this out the hard way. Klotz, the owner of a greeting card store on Austin Street, put up a Ferraro banner in front of his shop, only to have it torn down and some of the molding of his facade ripped off. Klotz defiantly put up the banner in the window instead. He also posted an anonymous letter he had received that criticized his politics: "We resent your attitude, and we resent Geraldine Ferraro. She doesn't represent the Forest Hills population, and the fact she lives in Forest Hills doesn't justify your brash display in your store windows." (Courtesy of the Queens Borough Public Library Archives, Joseph A. Ullman Photographs.)

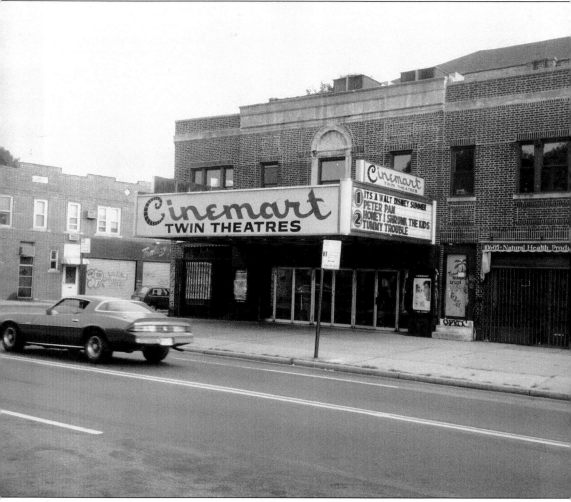

In the summer of 1989, the Cinemart movie theater on Metropolitan Avenue screens an all-Disney slate: a rerelease of the 1953 cartoon *Peter Pan*, the Rick Moranis movie *Honey, I Shrunk the Kids*, and the Roger Rabbit short *Tummy Trouble*. Thirty years earlier, the historic theater had a brush with the law over a movie seemingly as innocuous as those family-friendly flicks. On April 14, 1959, a special showing of the Charlie Chaplin comedy *Modern Times* drew an audience of about 450 to the theater, then known as the Inwood. Minutes before the movie was to begin, a federal marshal quietly entered the projection booth and seized the film. The drama stemmed from a legal debate over distribution rights to Chaplin movies, and many of the customers received refunds. The next night, the Inwood replaced its scheduled screening of *Modern Times* with six shorts—three with Chaplin and three with W.C. Fields. The Cinemart launched a website in the 1990s that billed the venue as the oldest continuously operated independent movie theater in Queens. (Courtesy of Queens Community Board 6.)

A 1990 photograph shows storefronts at the intersection of Yellowstone Boulevard and Selfridge Street, including a deli, People's bar, and the joint offices of assemblyman Alan Hevesi and state senator Emanuel Gold. A longtime powerbroker by the 1990s, Gold was just a novice in 1972 when he survived a Democratic primary challenge from Jerry Birbach, a vocal opponent of the Forest Hills housing project. (Courtesy of Queens Community Board 6.)

Drivers head east on a rain-slicked Austin Street on August 11, 1990. At left, the King George coffee shop operates out of one of the oldest commercial buildings in Forest Hills on the northeast corner of Austin Street and Continental Avenue. The building looks almost identical to its appearance in 1914, as pictured on the top of page 27. (Courtesy of Queens Community Board 6.)

During the first weekend after Memorial Day, residents of Forest Hills Gardens turn Flagpole Green into a neighborhood amusement park with games, inflatable slides, and carnival-style food. This tradition, known as Children's Day, has replaced Fourth of July speeches as the chief summertime celebration for the community. In this photograph, children hop around a bouncy castle on June 1, 1991. (Courtesy of the Forest Hills Gardens Corporation.)

The neon lights of a Roy Rogers restaurant glow on Continental Avenue near Queens Boulevard in 1991. Named after the cowboy movie actor, the chain is best known for hamburgers, roast beef sandwiches, and french fries. Advertised in the windows here are "Roy's wake-up specials," including a $2.99 deal for coffee, juice, a hash brown, and a sandwich with bacon, ham, or sausage. (Courtesy of Queens Community Board 6.)

Shoppers walk past PageAmerica, Annie's Franks & Fries, Broadway Bakery, and Cohen's Fashion Optical on the eastern side of Continental Avenue in 1995. Small banners that hang from the Broadway Bakery awning advertise coffee, pastry, cakes, bread, bagels, cookies, and pies. Across Austin Street, the former Corn Exchange Bank building houses a pharmacy named Prescription Headquarters. (Courtesy of Queens Community Board 6.)

In this 1995 photograph, a produce store and a nail salon sandwich Markwordt's, a go-to retailer for greeting cards, gifts, and candy on Austin Street. Just down the block, a Bareburger restaurant opened in March 2012 with an unusual selection of patties made from free-range ostrich, wild boar, and elk. (Courtesy of Queens Community Board 6.)

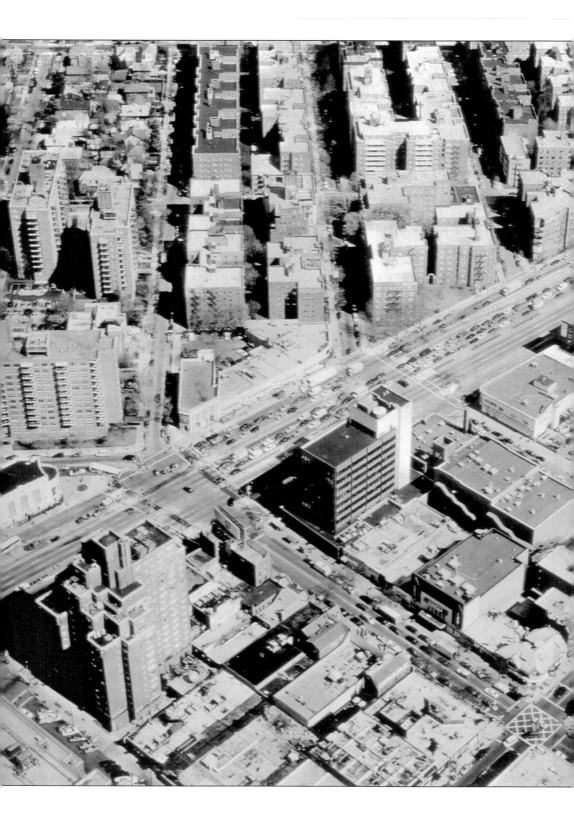

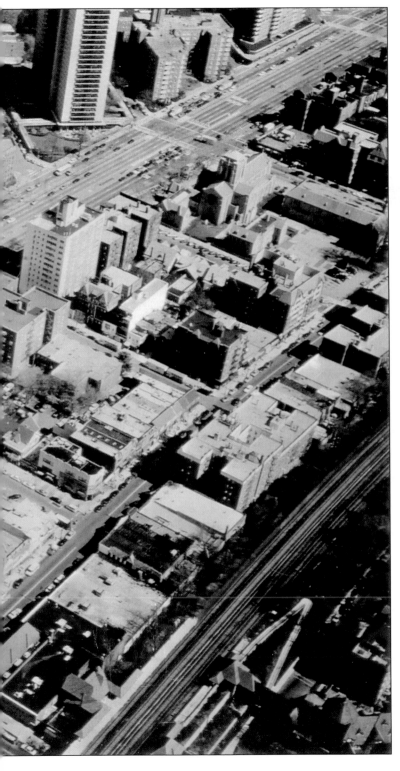

A century after Forest Hills was founded, this modern aerial photograph demonstrates the area's evolution from the rolling farms of Whitepot into a bustling neighborhood with a thriving commercial district and soaring apartment buildings. Many of the landmarks that represent the growth of the neighborhood still survive today, but others were lost to the wrecking ball in recent years. The Forest Hills Theatre on Continental Avenue was gutted, the mosaic ticket booth of the Trylon Theater on Queens Boulevard was destroyed, and pleasant single-family homes south of the Grand Central—including one owned by singer Al Jolson—were demolished to make way for gaudy McMansions. Even the fabled stadium of the West Side Tennis Club is deteriorating. Still, Forest Hills largely retains the charm that has lured residents for generations. (Courtesy of Cord Meyer Development Company.)

DISCOVER THOUSANDS OF LOCAL HISTORY BOOKS
FEATURING MILLIONS OF VINTAGE IMAGES

Arcadia Publishing, the leading local history publisher in the United States, is committed to making history accessible and meaningful through publishing books that celebrate and preserve the heritage of America's people and places.

Find more books like this at
www.arcadiapublishing.com

Search for your hometown history, your old stomping grounds, and even your favorite sports team.

Consistent with our mission to preserve history on a local level, this book was printed in South Carolina on American-made paper and manufactured entirely in the United States. Products carrying the accredited Forest Stewardship Council (FSC) label are printed on 100 percent FSC-certified paper.

MADE IN THE USA